how to draw
HiP-HOP

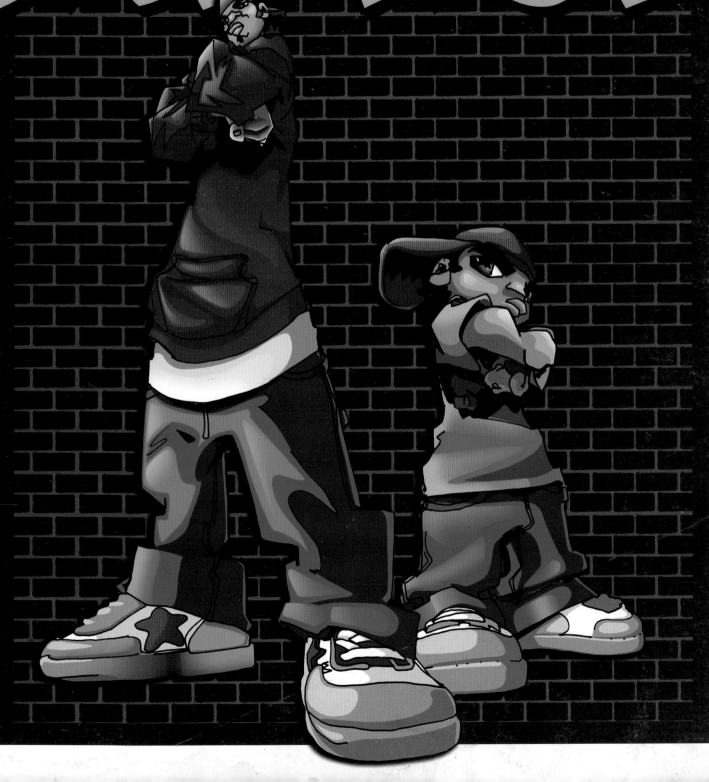

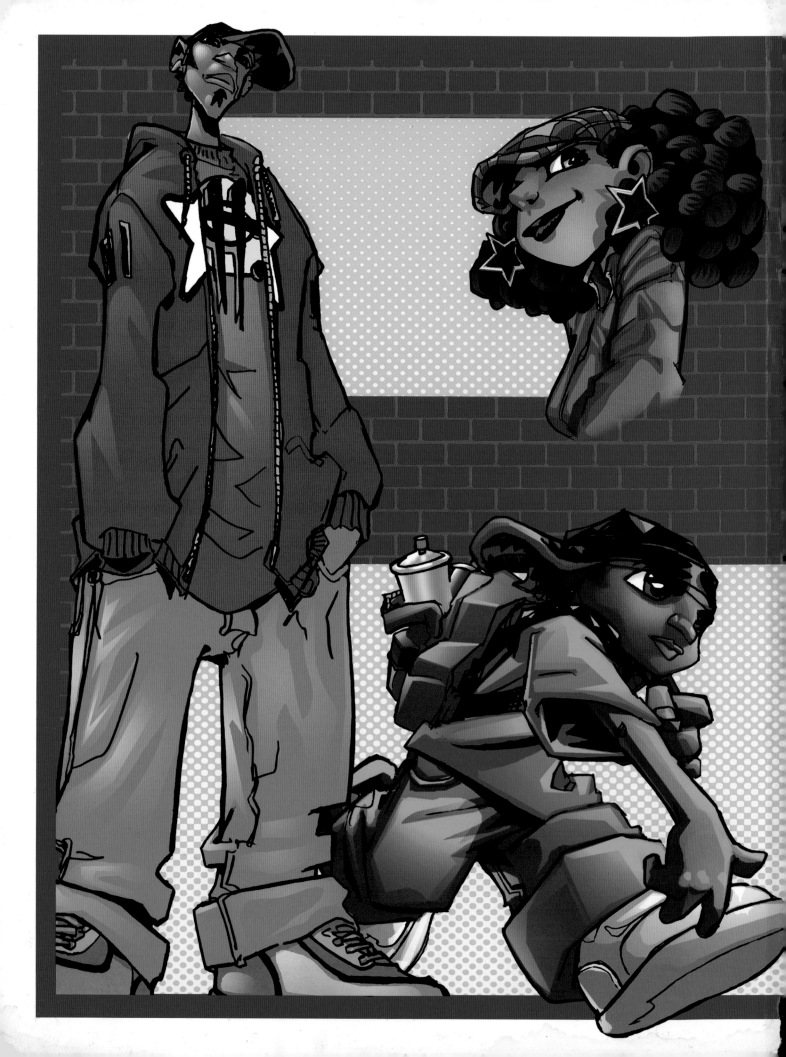

how to draw HiP-HOP

Damion Scott
and Kris Ex

WATSON-GUPTILL PUBLICATIONS, NEW YORK

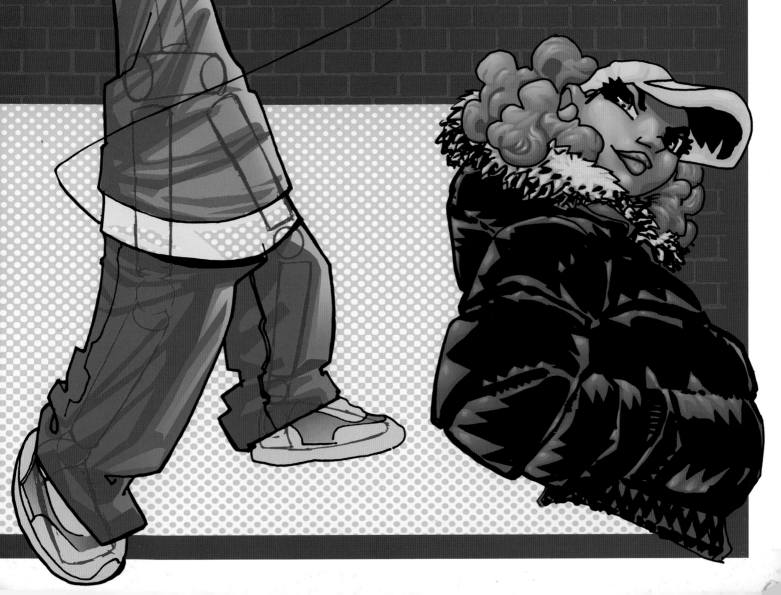

SENIOR ACQUISITIONS EDITOR: CANDACE RANEY
DEVELOPMENTAL EDITOR: JOSEPH ILLIDGE
DESIGN AND COLOR: MADA DESIGN, INC.
PRODUCTION MANAGER: HECTOR CAMPBELL

FIRST PUBLISHED IN 2006
BY WATSON-GUPTILL PUBLICATIONS,
A DIVISION OF VNU BUSINESS MEDIA, INC.
770 BROADWAY, NEW YORK, NY 10003
WWW.WGPUB.COM

LIBRARY OF CONGRESS
CATALOGING-IN-PUBLICATION DATA
SCOTT, DAMION.
 HOW TO DRAW HIP-HOP / BY DAMION SCOTT, KRIS EX.
 P. CM
 ISBN 0-8230-1446-0
1. HIP-HOP. 2. DRAWING--TECHNIQUE. I. EX,KRIS. II. TITLE.
 NC825.H57S36 2006
 741.2--DC22 2005029156

PRINTED IN CHINA

FIRST PRINTING, 2006

1 2 3 4 5 6 7 8 / 12 11 10 09 08 07 06

Introduction 7

CHAPTER ONE: tools and supplies 10

CHAPTER TWO: shape and form 20

CHAPTER THREE: construction 32

CHAPTER FOUR: gear 64

CHAPTER FIVE:
posture and characterization 82

CHAPTER SIX: movement 102

CHAPTER SEVEN: locomotion 112

CHAPTER EIGHT: style 122

Epilogue 133

Index 144

DEDICATIONS:

In loving memory of my brother,
Kevin Bennet, who in life introduced me to the
pencil line, and in death introduced me to life.
-Damion Scott

In loving memory of my niece,
Alyssa Marie. You're a great teacher.
We miss you.
-kris ex

And all the pioneers, visionaries, and
entrepreneurs who made this book
possible and necessary.

INTRODUCTION

The main question we were asked whenever either of us told someone we were working on a book called "How To Draw Hip-Hop" was fairly obvious: How do you draw hip-hop? Our answer was quite obvious as well: Buy the book.

Now that you have done so (unless you're just thumbing through this in the bookstore, to which we say: Buy the book or get your grubby hands off it) you, too, can learn to draw hip-hop. Kinda, sorta. Hip-hop has its roots in individual expression, spontaneous creativity, haphazard fashion, and rebellious "flair. With this understanding, it must be said that a book on "how to draw hip-hop" is defeated before the first word has even been written because hip-hop has to follow the rules while discarding them, reinventing them, and creating new ones; hip-hop has to stay within the lines, even as it pushes them, contorting boundaries into new shapes, figures, and unseen expressions. So, really it's a fool's errand to instruct you on how to draw hip-hip—it is, in essence, attempting to teach the unteachable. Luckily for you, you have found not one, but two fools willing to explain the unexplainable by giving you the laws that you must almost necessarily violate in order to create anything worthy of being considered hip-hop.

This book is only a starting point. No one tome, no matter how well-crafted, can capture the ever-changing energy of hip-hop. And, logically, no one book can substitute for an entire art course. It would be stupid of us to try to make hip-hop static, to put it into words and make this book a paint-by-numbers exercise—and it would be silly of you to believe that we have done so. Just as there is no true consensus as to what constitutes hip-hop, there can be no definitive instruction as to the drawing of a cultural force that encompasses music, dance, art, fashion, poetry, and more. What we have done with this book is capture a small slice from the essence of the thirty-year-old folk art, billion-dollar industry, and worldwide phenomenon that has consumed and revamped other musical styles while redefining the advertising, art, and fashion industries. We've taken the prismatic artistic expression that began in the projects of New York's South Bronx during the 1970s and looked at it as it relates to drawing. And, even on that front, we've only begun to scratch the surface.

None of this is to say that we've shortchanged you on instruction—because we haven't. We provide you with the basic foundations of drawing: shapes, construction, composition, and all that good stuff. But we haven't gone into too much detail about certain aspects of art instruction, opting to present a broad overview of some of the finer points that make hip-hop drawing a separate breed from more general art forms. For instance, we've bypassed elongated discussions of perspective and shading in lieu of more detailed instruction about clothes and accessories. While the drawings here may depict specific hip-hop styles that are in fashion as of this writing (not to mention the artist's particular brand of expression), the instruction sets its aims on the spirit of what makes the styles "hip-hop," in order to give you the ability to stay abreast of hip-hop's permutations and illustrate your own creations. We don't give you a basket of fish, we lead you to the water and show you what a fish is. From there, you're on your own. That's how it was in the beginning, and that's how it should remain.

Hip-hop is a force majeure, a vibrant, moving, breathing energy. It is not a creation as much as it is a potent potentiality, formulating and reformulating itself at all times. Even as you read this, new forms, idioms, and denominations are coming into existence under the banner of hip-hop. New connections are being made, unheralded forms are being constructed, and virgin styles are being birthed. It may be impossible to catch this creative lightning in a bottle and have it pose for a picture, but it is relatively easy to learn some of the properties of this energy. To that end, this book is not about teaching as much as it is about educating. Our goal is to instruct you on the movements, logic, mathematics, and philosophy of this energy. Perhaps then you can begin to predict where it will go. Figure out its next movement, then draw that. Then, and only then, will you truly begin to draw hip-hop.

So if you haven't bought this book yet, what are you waiting for?

Damion Scott
Kris Ex
New York 2005

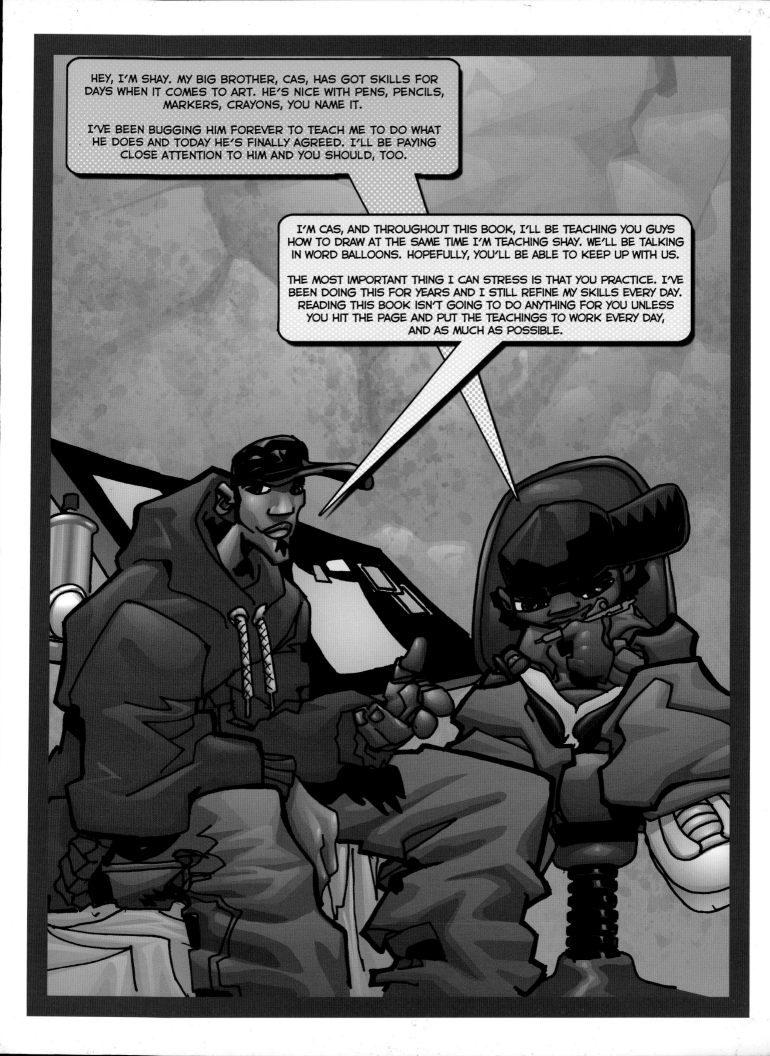

chapter one

tools and supplies

FIRST THING YOU HAVE TO DO IS GET YOUR TOOLS. THIS SEEMS PRETTY BASIC, BUT YOU'LL MOST LIKELY SPEND MONTHS, IF NOT YEARS, EXPERIMENTING WITH DIFFERENT TOOLS UNTIL YOU FIND THE COMBINATION THAT SUITS YOUR STYLE BEST. DON'T BE INTIMIDATED BY THE ONSLAUGHT OF EQUIPMENT. JUST MIX AND MATCH TO FIT WHAT YOU NEED.

WE HAVE PENCILS.

PENCILS? I USE PENCILS IN SCHOOL.

YOU USE PLAIN OLD NUMBER 2 PENCILS IN SCHOOL. I'M TALKING ABOUT GRAPHIC PENCILS. ART PENCILS COME IN DIFFERENT KINDS OF GRAPHITE. (THERE'S ACTUALLY NO LEAD IN PENCILS AND IF THAT INFORMATION WINS YOU SOME MONEY ON A GAME SHOW, I WANT MY CUT!) THE MOST COMMON DISTINCTIONS ARE "H," "B," OR "F" PENCILS. THE "H" REFERS TO THE HARDNESS OF THE PENCIL CORE, THE "B" INDICATES HOW DARK THE PENCIL IS, AND THE "F" MEANS THAT THE PENCIL CAN BE SHARPENED TO A FINE POINT. IT'S NOT UNCOMMON TO SEE COMBINATIONS SUCH AS "HB," WHICH MEANS IT'S A HARD AND BLACK PENCIL. OTHERS WILL USE NUMBERS SUCH AS "2H" OR EVEN "3HB" TO INDICATE THE PROPERTIES OF THE GRAPHITE, GOT IT?

IS THIS GONNA BE ON THE TEST?

WHEN IT COMES TO MARKERS, YOUR MAIN CHOICES ARE PERMANENT MARKERS VS. NON-PERMANENT. PERMANENT MARKERS WORK ON MOST SURFACES AND ARE WATERPROOF. MAKING THEM GREAT FOR WORKING ON CLOTHING. BUT WHEN YOU USE A PERMANENT MARKER, ANY MISTAKES YOU MAKE WILL HANG AROUND ANYWHERE BETWEEN A FEW MONTHS AND THE TIME WHEN THERE'S NOTHING BUT COCKROACHES ROAMING THE PLANET. NON-PERMANENT MARKERS ARE WATER-BASED SO THAT YOU CAN ERASE MISTAKES, BUT IF YOU USE THEM ON CLOTHES, THEY'LL BLEED AND RUN IN THE WASH.

ALL OF THESE COME IN VARIOUS TEXTURES, SIZES, AND COLORS. EACH ONE IS GOING TO GIVE YOU A DIFFERENT EFFECT. AS A RULE OF THUMB, YOU SHOULD MAKE SURE ANYTHING YOU USE IS NON-TOXIC. THINK LONG AND HARD BEFORE USING ANYTHING THAT HAS A WARNING LABEL.

PENCILS: DON'T BE SURPRISED IF SOME OF THESE ARE ROUND.

PILOT™ PEN: CAN'T FLY, BUT THEY'RE GOOD FOR SKETCHING OR FINISHING LINE WORK.

OIL MARKER: NOT SUITABLE FOR COOKING.

OIL

OIL

MECHANICAL PENCIL: IT IS A PENCIL, BUT YOU CHANGE THE GRAPHITE YOURSELF TO KEEP THE POINT SHARP.

FATHEAD MARKER: SIZE DOES MATTER.

PERMANENT MARKER: NOT TO BE USED FOR DEFACING PUBLIC OR PRIVATE PROPERTY.

ON THE HIGHER END OF THINGS, IF YOU WANT TO GET INTO ACTUAL PAINTING AND WORKING ON HARDER SURFACES, THEN YOU'LL HAVE TO GET FAMILIAR WITH ACRYLICS, OILS, AND WATERCOLOR—ALL OF WHICH ARE APPLIED WITH BRUSHES.

BRUSHES ARE MUCH HARDER TO MASTER THAN PENS AND MARKERS AND REQUIRE MUCH MORE CARE, SO I DON'T SUGGEST ANYONE STARTING OFF WITH THEM UNLESS YOU'VE ALREADY HAD EXPERIENCE USING THEM.

THEY'RE ALSO MESSIER, SO DON'T WEAR YOUR SUNDAY'S BEST WHEN PAINTING WITH BRUSHES.

AND WHAT'S THE SPRAY PAINT FOR?

IN THE PAST, SPRAY PAINT WAS MAINLY USED FOR GRAFFITI-TERRITORIAL MARKINGS AND THE WORDS OF PROPHETS. BUT NOW I KEEP IT ON HAND IN CASE I'M COMMISSIONED TO DO A PIECE FOR A STORE OR SOMETHING LIKE THAT.

AND I ALWAYS TAKE MY GOGGLES AND MASK WITH ME. AS A MATTER OF FACT, ANY TIME YOU'RE WORKING WITH PAINTS, YOU'D BE WISE TO DON A MASK.

GOGGLES & MASK: PROTECT YOUR NECK—OR AT LEAST YOUR MUCUS MEMBRANES.

SPRAY PAINT: IN MOST STATES, IT IS ILLEGAL TO ENGAGE IN THE SALE OR DISTRIBUTION OF SPRAY PAINT TO PERSONS UNDER EIGHTEEN YEARS OF AGE.

PAINTS: FOR USE WITH BRUSHES.

INKS: FOR REFILLING PENS AND MARKERS, WORKING WITH BRUSHES.

BRUSHES: YOU COULD USE THESE TO PAINT YOUR LIVING ROOM, BUT THAT MAY TAKE A WHILE.

WATER-RESISTANT PAINT: WON'T RUN IN THE WASH.

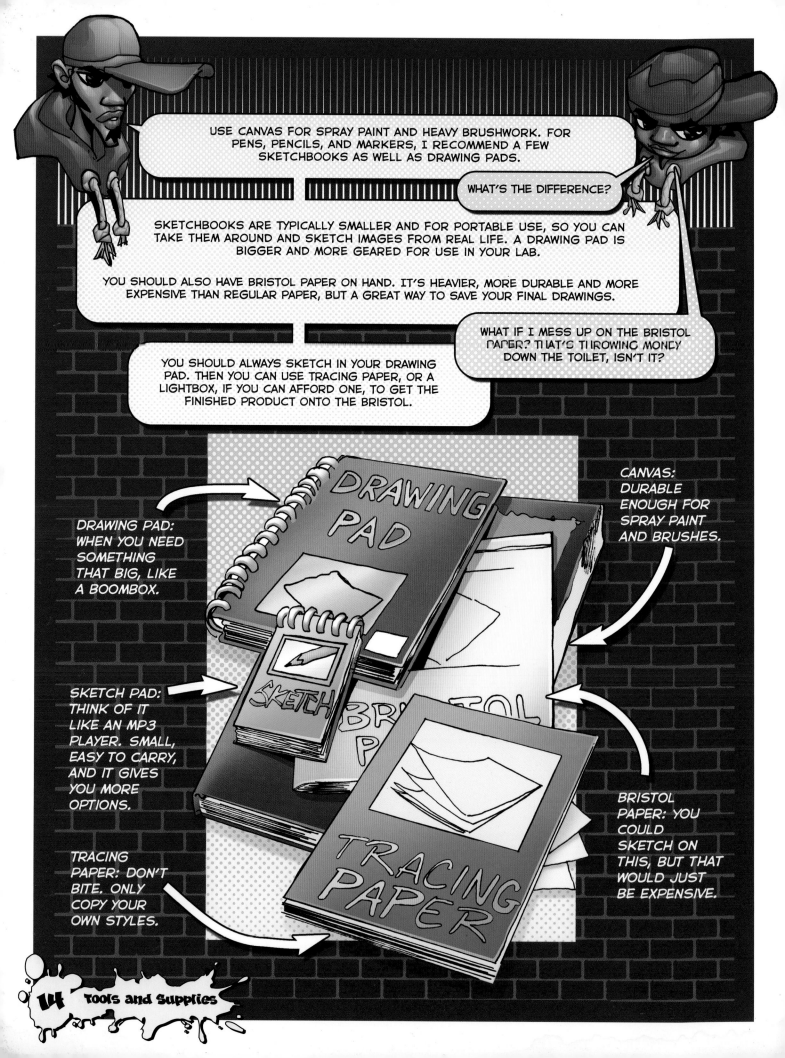

USE CANVAS FOR SPRAY PAINT AND HEAVY BRUSHWORK. FOR PENS, PENCILS, AND MARKERS, I RECOMMEND A FEW SKETCHBOOKS AS WELL AS DRAWING PADS.

WHAT'S THE DIFFERENCE?

SKETCHBOOKS ARE TYPICALLY SMALLER AND FOR PORTABLE USE, SO YOU CAN TAKE THEM AROUND AND SKETCH IMAGES FROM REAL LIFE. A DRAWING PAD IS BIGGER AND MORE GEARED FOR USE IN YOUR LAB.

YOU SHOULD ALSO HAVE BRISTOL PAPER ON HAND. IT'S HEAVIER, MORE DURABLE AND MORE EXPENSIVE THAN REGULAR PAPER, BUT A GREAT WAY TO SAVE YOUR FINAL DRAWINGS.

WHAT IF I MESS UP ON THE BRISTOL PAPER? THAT'S THROWING MONEY DOWN THE TOILET, ISN'T IT?

YOU SHOULD ALWAYS SKETCH IN YOUR DRAWING PAD. THEN YOU CAN USE TRACING PAPER, OR A LIGHTBOX, IF YOU CAN AFFORD ONE, TO GET THE FINISHED PRODUCT ONTO THE BRISTOL.

DRAWING PAD: WHEN YOU NEED SOMETHING THAT BIG, LIKE A BOOMBOX.

CANVAS: DURABLE ENOUGH FOR SPRAY PAINT AND BRUSHES.

SKETCH PAD: THINK OF IT LIKE AN MP3 PLAYER. SMALL, EASY TO CARRY, AND IT GIVES YOU MORE OPTIONS.

TRACING PAPER: DON'T BITE. ONLY COPY YOUR OWN STYLES.

BRISTOL PAPER: YOU COULD SKETCH ON THIS, BUT THAT WOULD JUST BE EXPENSIVE.

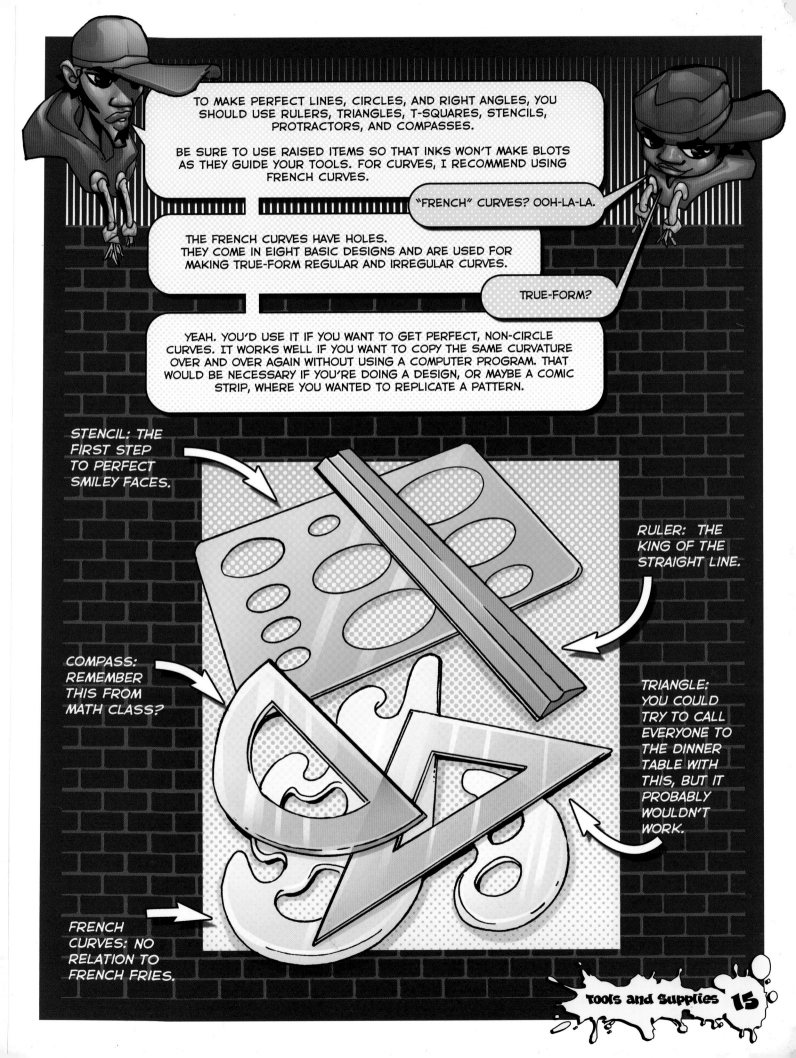

TO MAKE PERFECT LINES, CIRCLES, AND RIGHT ANGLES, YOU SHOULD USE RULERS, TRIANGLES, T-SQUARES, STENCILS, PROTRACTORS, AND COMPASSES.

BE SURE TO USE RAISED ITEMS SO THAT INKS WON'T MAKE BLOTS AS THEY GUIDE YOUR TOOLS. FOR CURVES, I RECOMMEND USING FRENCH CURVES.

"FRENCH" CURVES? OOH-LA-LA.

THE FRENCH CURVES HAVE HOLES.
THEY COME IN EIGHT BASIC DESIGNS AND ARE USED FOR MAKING TRUE-FORM REGULAR AND IRREGULAR CURVES.

TRUE-FORM?

YEAH. YOU'D USE IT IF YOU WANT TO GET PERFECT, NON-CIRCLE CURVES. IT WORKS WELL IF YOU WANT TO COPY THE SAME CURVATURE OVER AND OVER AGAIN WITHOUT USING A COMPUTER PROGRAM. THAT WOULD BE NECESSARY IF YOU'RE DOING A DESIGN, OR MAYBE A COMIC STRIP, WHERE YOU WANTED TO REPLICATE A PATTERN.

STENCIL: THE FIRST STEP TO PERFECT SMILEY FACES.

RULER: THE KING OF THE STRAIGHT LINE.

COMPASS: REMEMBER THIS FROM MATH CLASS?

TRIANGLE: YOU COULD TRY TO CALL EVERYONE TO THE DINNER TABLE WITH THIS, BUT IT PROBABLY WOULDN'T WORK.

FRENCH CURVES: NO RELATION TO FRENCH FRIES.

CHAPTER TWO

shape and form

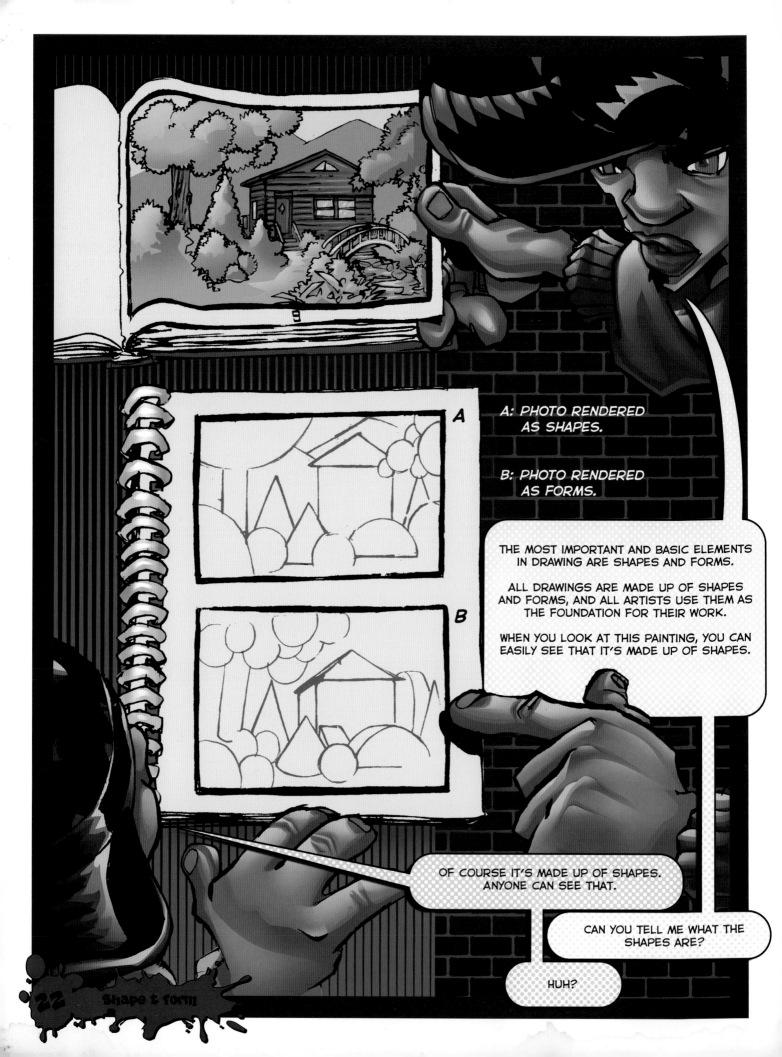

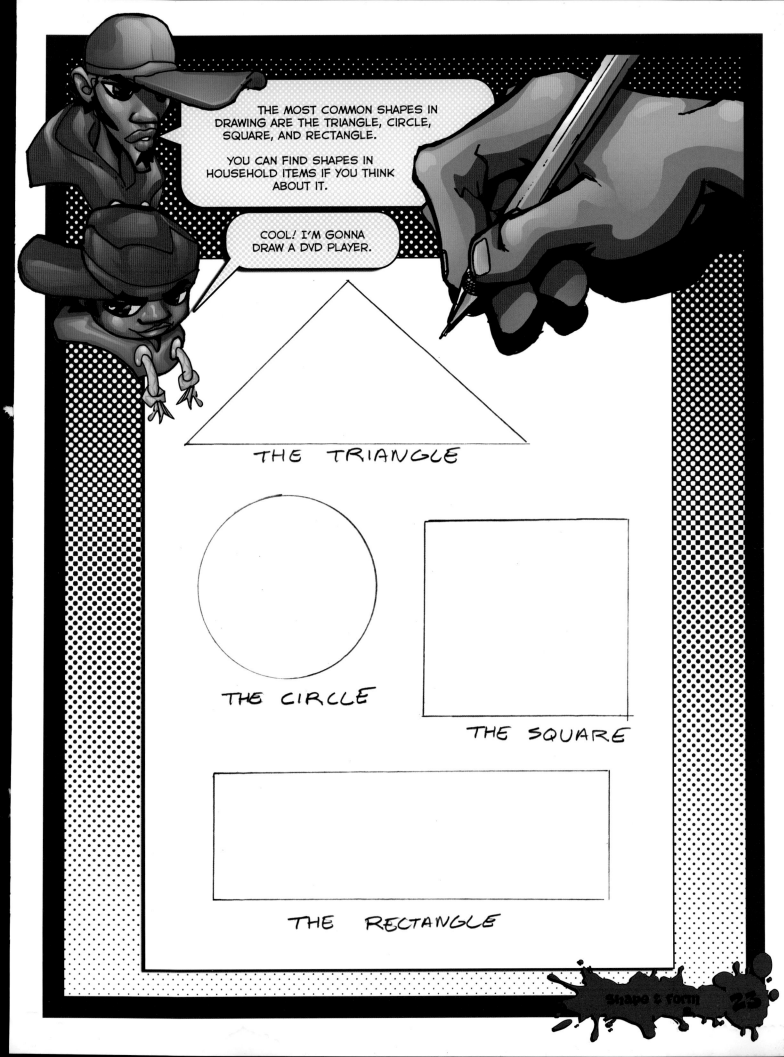

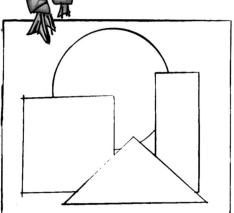

A - YOU CAN CREATE THE ILLUSION OF DISTANCE BY OVERLAPPING SHAPES.

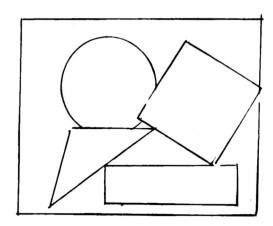

B - EXPERIMENT WITH BALANCE AND WEIGHT.

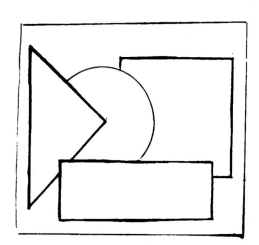

C - USE RANDOM COMBINATIONS TO LEAD THE VIEWER'S EYE AROUND THE PICTURE.

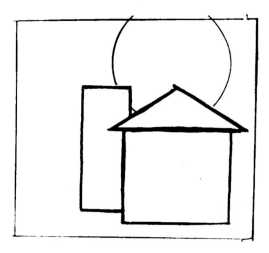

D - CONVINCING SCENES AND ENVIRONMENTS BEGIN WITH COMPOSING SHAPES PROPERLY.

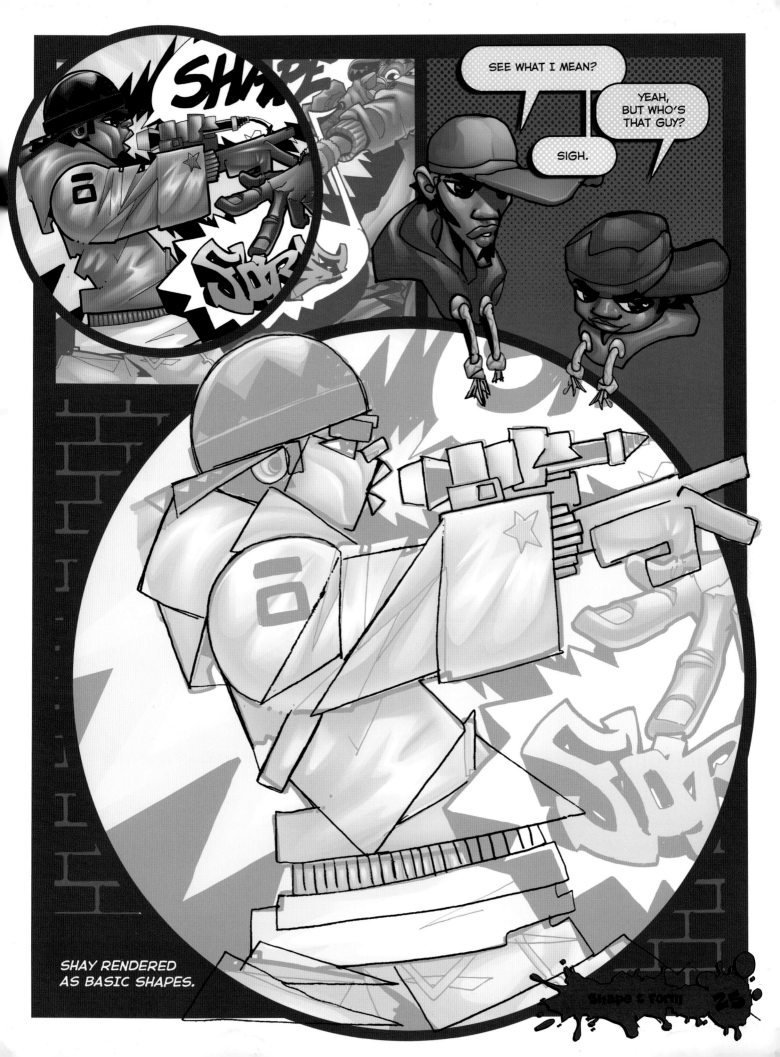

SHAY RENDERED
AS BASIC SHAPES.

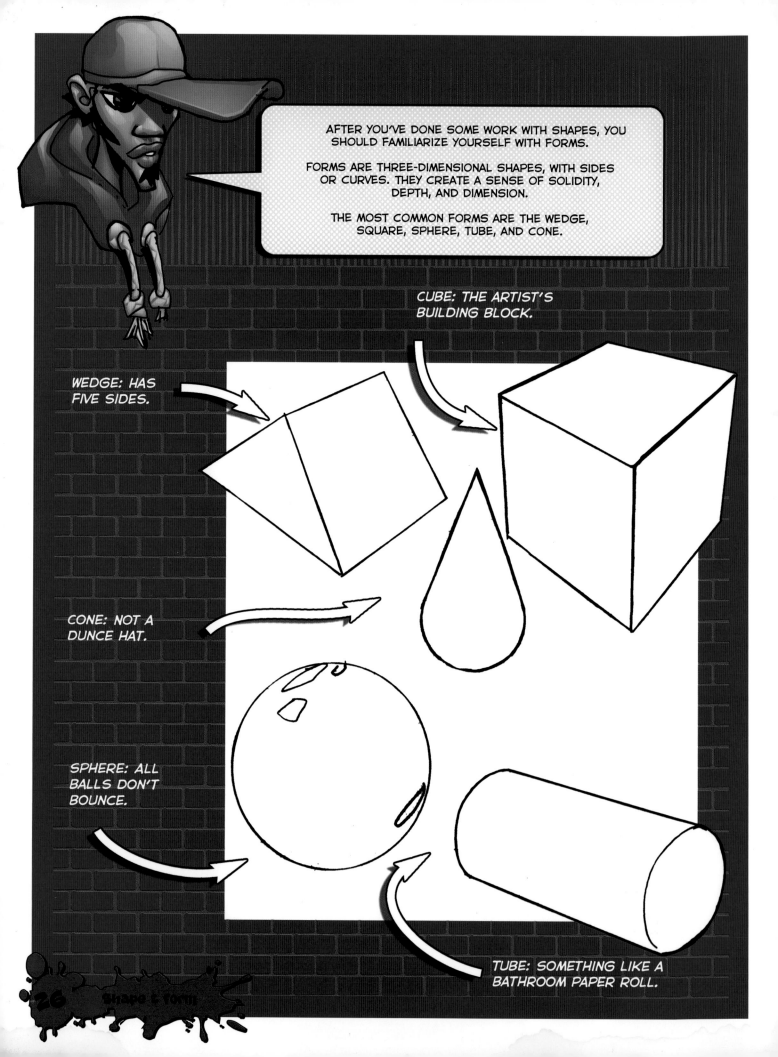

AFTER YOU'VE DONE SOME WORK WITH SHAPES, YOU SHOULD FAMILIARIZE YOURSELF WITH FORMS.

FORMS ARE THREE-DIMENSIONAL SHAPES, WITH SIDES OR CURVES. THEY CREATE A SENSE OF SOLIDITY, DEPTH, AND DIMENSION.

THE MOST COMMON FORMS ARE THE WEDGE, SQUARE, SPHERE, TUBE, AND CONE.

CUBE: THE ARTIST'S BUILDING BLOCK.

WEDGE: HAS FIVE SIDES.

CONE: NOT A DUNCE HAT.

SPHERE: ALL BALLS DON'T BOUNCE.

TUBE: SOMETHING LIKE A BATHROOM PAPER ROLL.

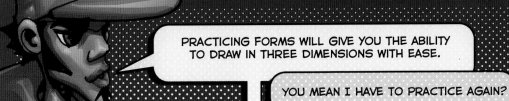

PRACTICING FORMS WILL GIVE YOU THE ABILITY TO DRAW IN THREE DIMENSIONS WITH EASE.

YOU MEAN I HAVE TO PRACTICE AGAIN?

YEAH. JUST LIKE YOU DID WITH THE SHAPES.

YOU CAN THROW TRACING PAPER ON TOP OF YOUR SHAPE COMPOSITIONS AND JUST ADD THE DEPTH. THAT WAY, YOU GET SOME EXPERIENCE WORKING WITH TRACING PAPER, AS WELL.

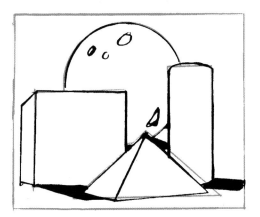

A: NOTICE HOW THE ILLUSION OF DISTANCE IS IMPROVED WHEN YOU OVERLAP FORMS AS OPPOSED TO SHAPES. ADDING SHADOWS WILL MAKE YOUR DRAWINGS MUCH MORE REALISTIC.

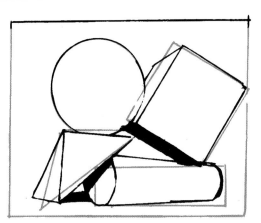

B: EXPERIMENT FURTHER WITH BALANCE AND WEIGHT, ONCE AGAIN TAKING NOTE OF SHADOWS.

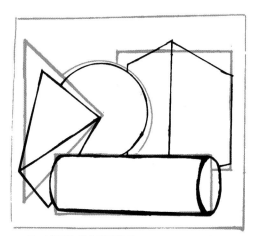

C: USE RANDOM COMBINATIONS TO CREATE MOVEMENT AND TENSION IN YOUR WORK.

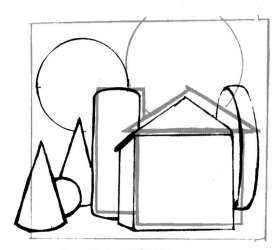

D: WELL-DEFINED ENVIRONMENTS RELY ON THE PROPER USE OF FORMS.

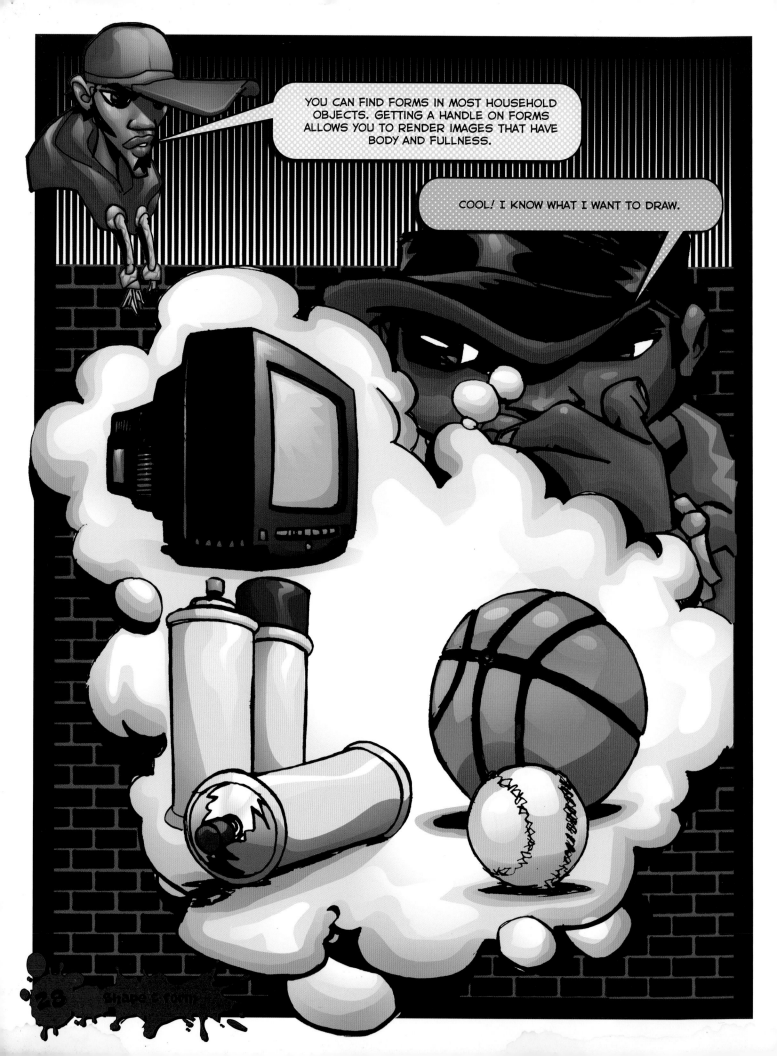

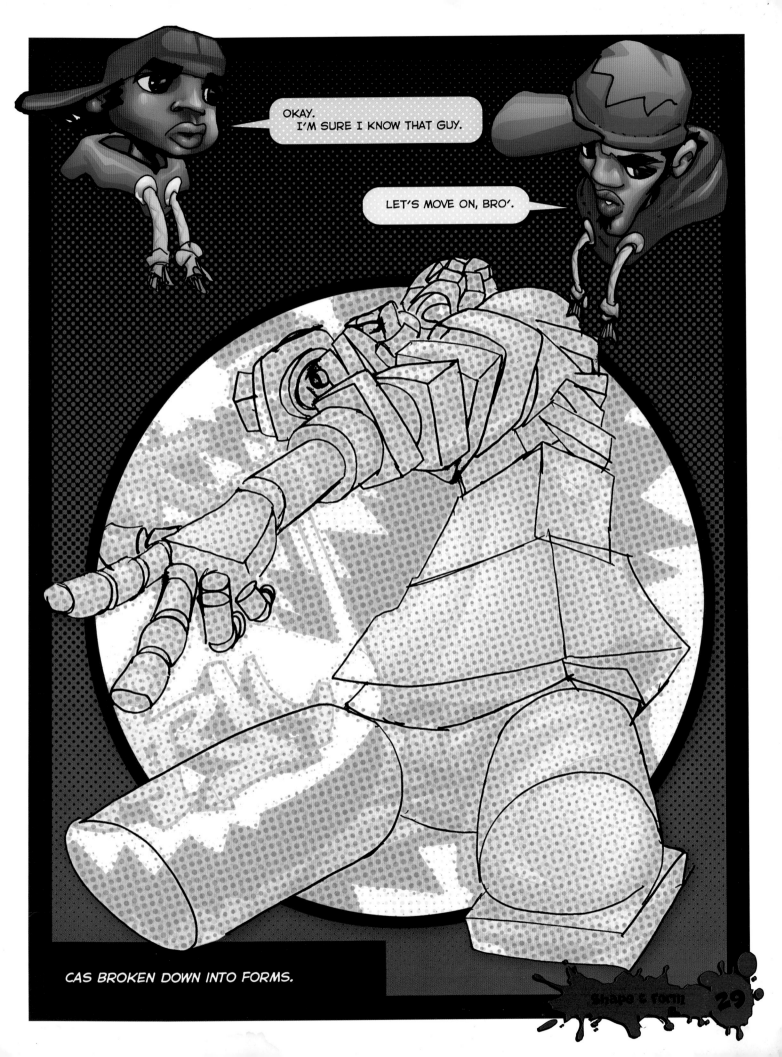

CAS BROKEN DOWN INTO FORMS.

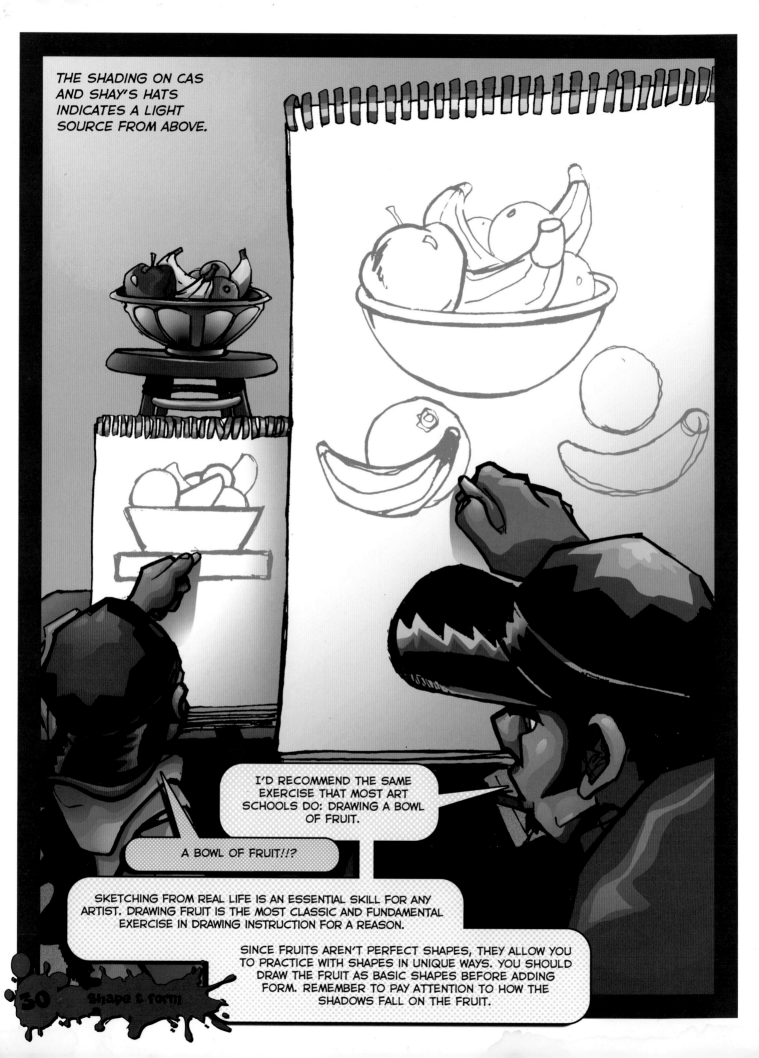

THE SHADING ON CAS AND SHAY'S HATS INDICATES A LIGHT SOURCE FROM ABOVE.

I'D RECOMMEND THE SAME EXERCISE THAT MOST ART SCHOOLS DO: DRAWING A BOWL OF FRUIT.

A BOWL OF FRUIT!!?

SKETCHING FROM REAL LIFE IS AN ESSENTIAL SKILL FOR ANY ARTIST. DRAWING FRUIT IS THE MOST CLASSIC AND FUNDAMENTAL EXERCISE IN DRAWING INSTRUCTION FOR A REASON.

SINCE FRUITS AREN'T PERFECT SHAPES, THEY ALLOW YOU TO PRACTICE WITH SHAPES IN UNIQUE WAYS. YOU SHOULD DRAW THE FRUIT AS BASIC SHAPES BEFORE ADDING FORM. REMEMBER TO PAY ATTENTION TO HOW THE SHADOWS FALL ON THE FRUIT.

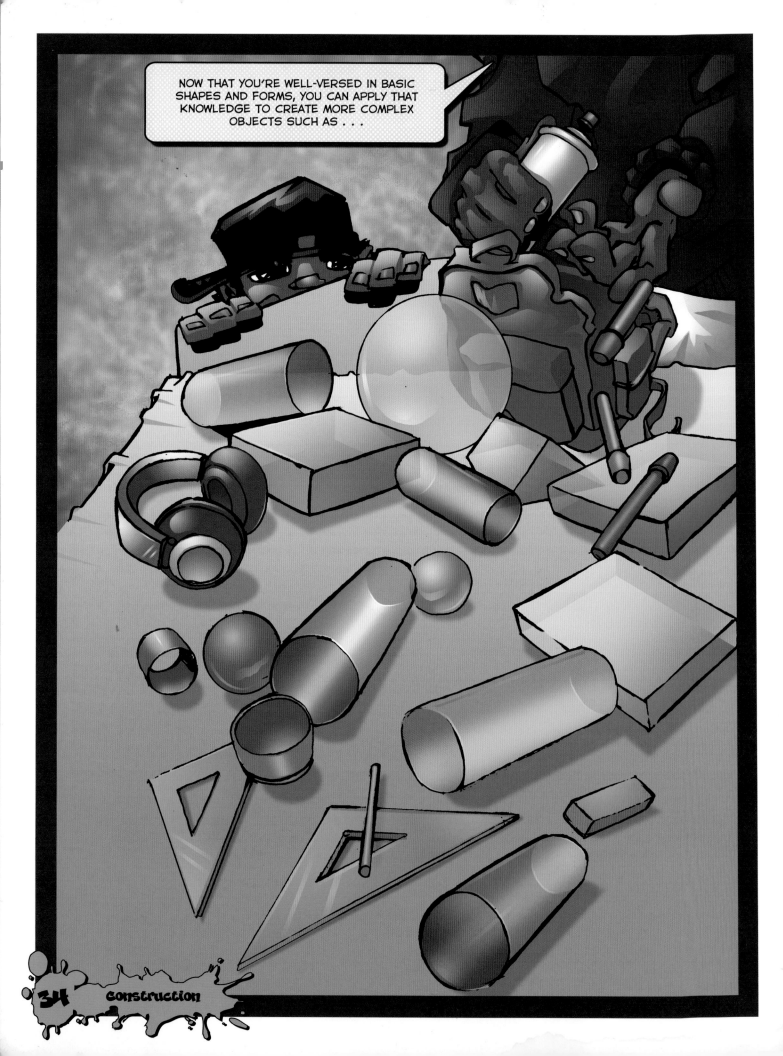

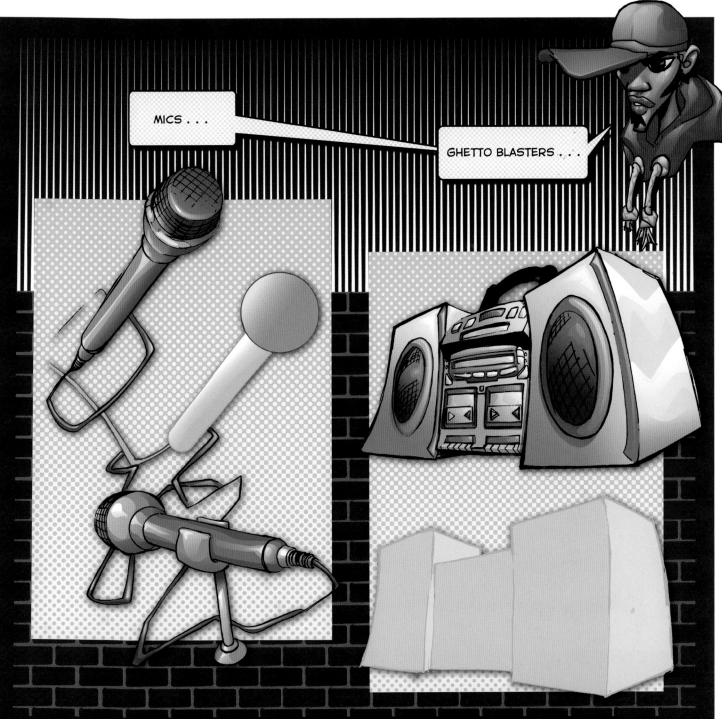

MICS . . .

GHETTO BLASTERS

A MICROPHONE IS COMPRISED OF A SPHERE AND A TUBE. A MICROPHONE IS THE PRIME WEAPON IN AN MC'S ARSENAL. MICS SHOULD BE DRAWN LARGE, BUT NOT COMICALLY SO—LARGE ENOUGH TO FEEL LIKE A MAGIC WAND WITHOUT ACTUALLY LOOKING LIKE ONE. THE BARREL SHOULD BE THICK, THE HEAD RESONATING WITH POWER. TECHNOLOGY MAY HAVE EVOLVED TO A POINT WHERE WIRELESS MICS ARE PRETTY COMMONPLACE, BUT FOR ARTISTIC PURPOSES, IT'S GOOD TO STICK WITH WIRED MICS. THE WIRE NEVER HANGS STRAIGHT DOWN. IT IS A DRAMATIC TOOL, CRACKLING WITH ELECTRICITY AND DEFYING GRAVITY.

A BOOM BOX IS BUILT ON CUBES, THE BIGGER THE BETTER. AS BOOM BOXES REPRESENT SOUND, YOU SHOULD DRAW THEM WITH A SENSE OF MOVEMENT. NOTICE HOW THE CURVATURE OF THE BOX'S SPEAKERS MAKE IT SEEM AS IF IT'S DANCING.

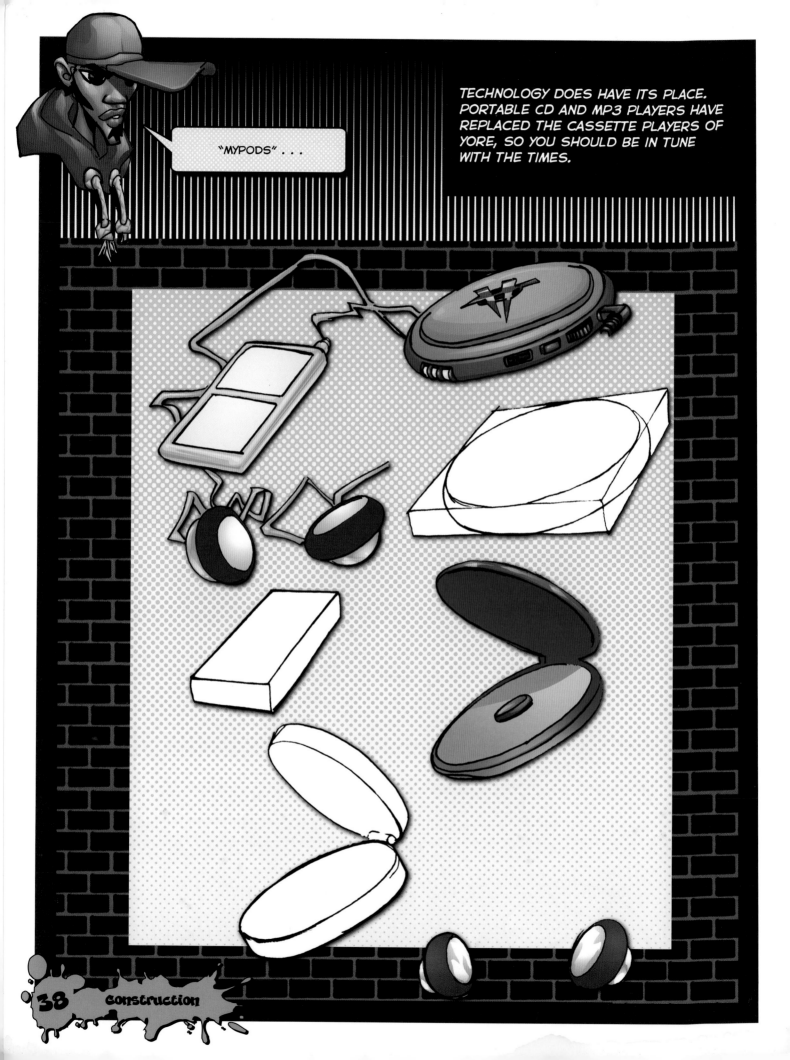

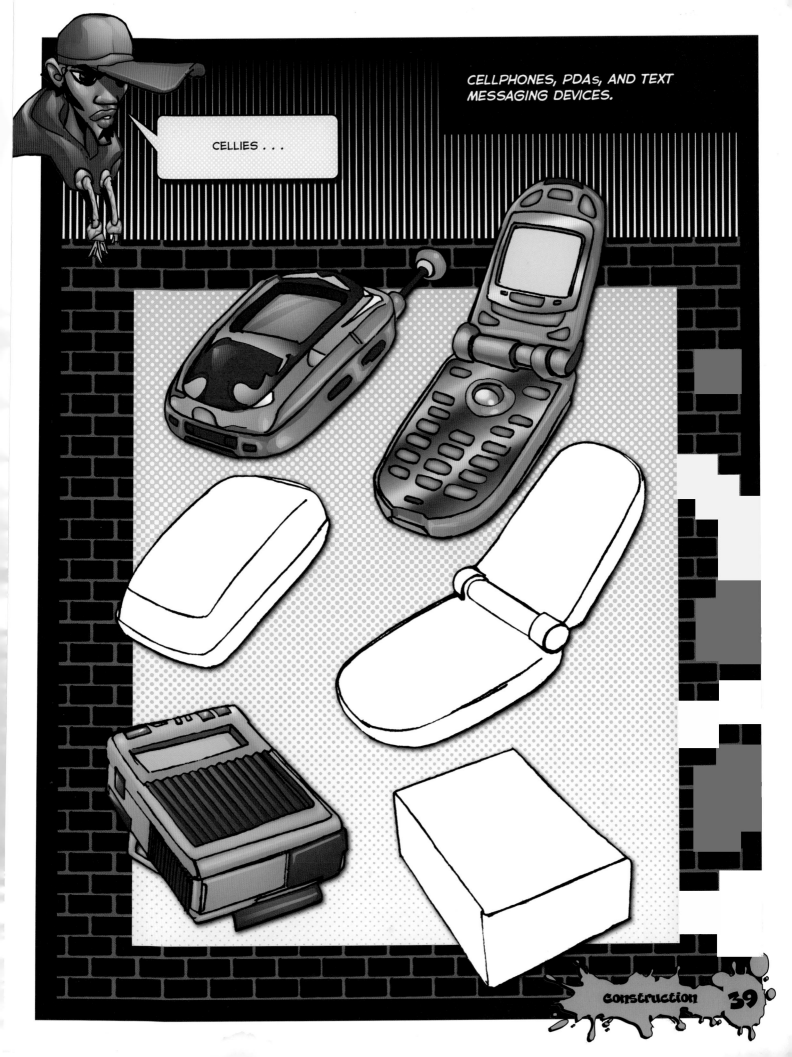

CELLPHONES, PDAs, AND TEXT MESSAGING DEVICES.

CELLIES . . .

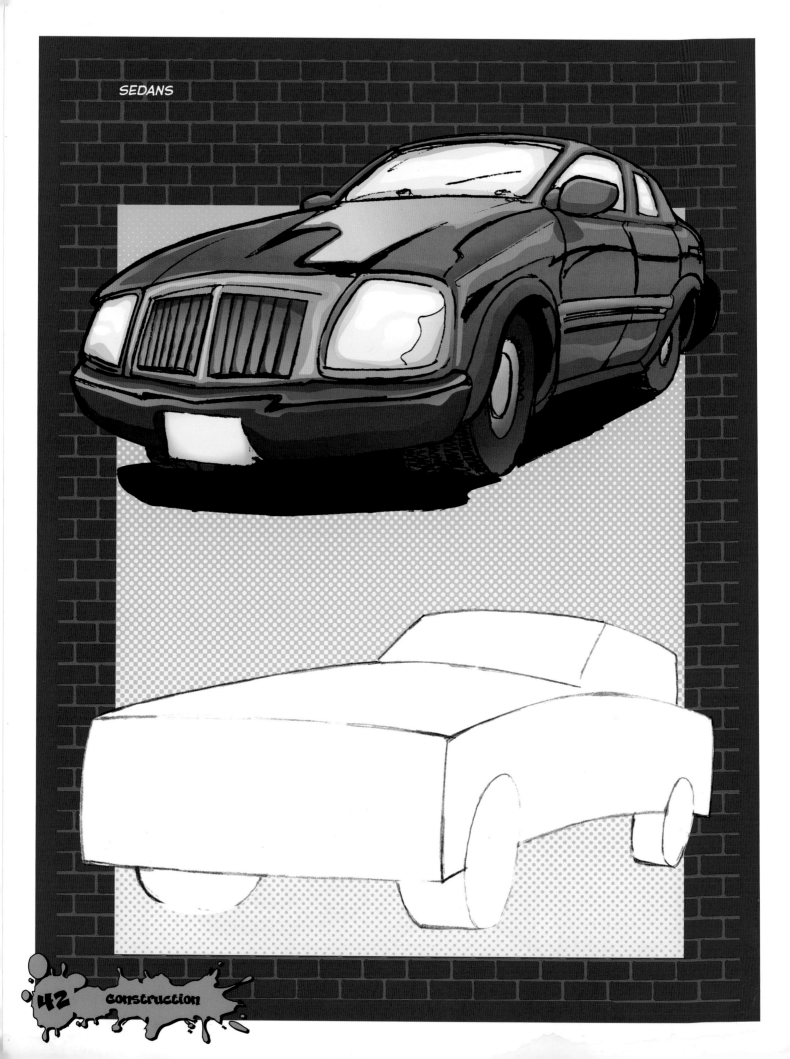

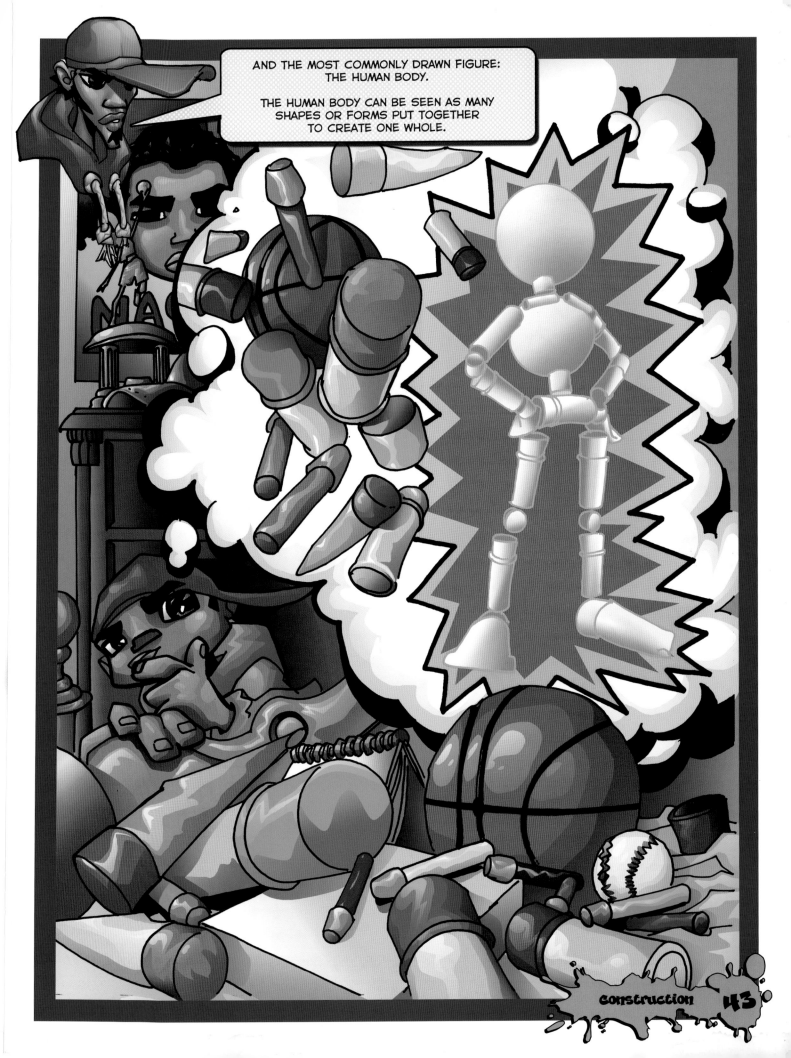

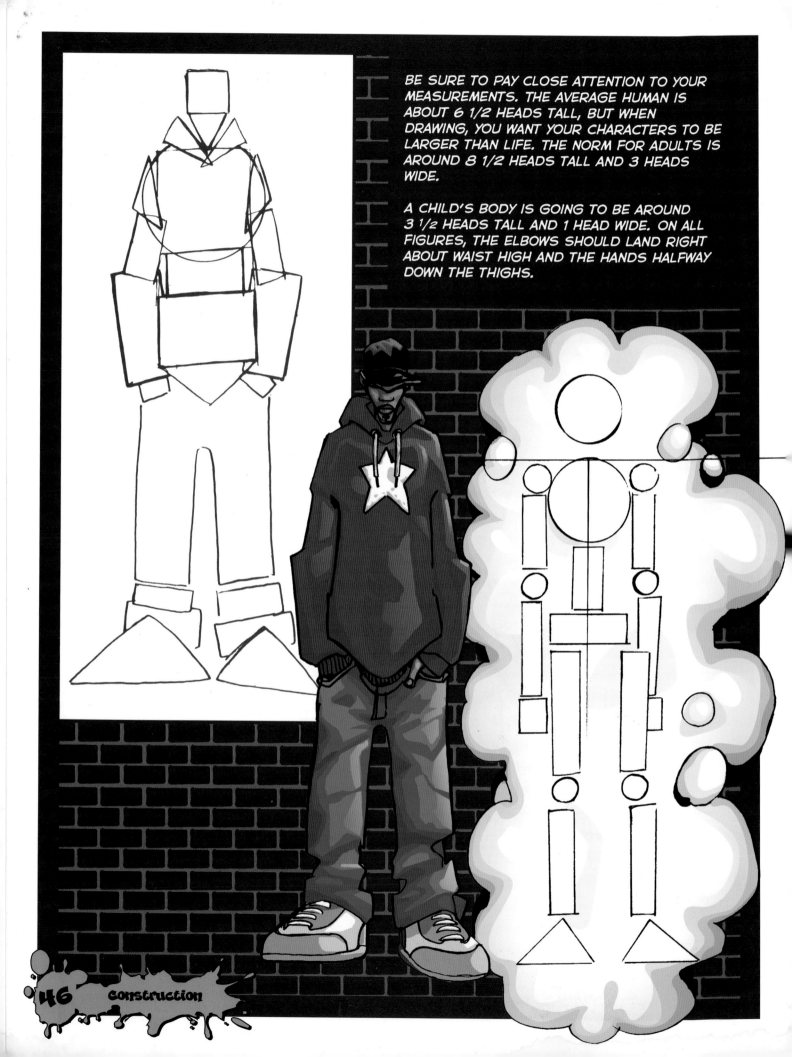

BE SURE TO PAY CLOSE ATTENTION TO YOUR MEASUREMENTS. THE AVERAGE HUMAN IS ABOUT 6 1/2 HEADS TALL, BUT WHEN DRAWING, YOU WANT YOUR CHARACTERS TO BE LARGER THAN LIFE. THE NORM FOR ADULTS IS AROUND 8 1/2 HEADS TALL AND 3 HEADS WIDE.

A CHILD'S BODY IS GOING TO BE AROUND 3 1/2 HEADS TALL AND 1 HEAD WIDE. ON ALL FIGURES, THE ELBOWS SHOULD LAND RIGHT ABOUT WAIST HIGH AND THE HANDS HALFWAY DOWN THE THIGHS.

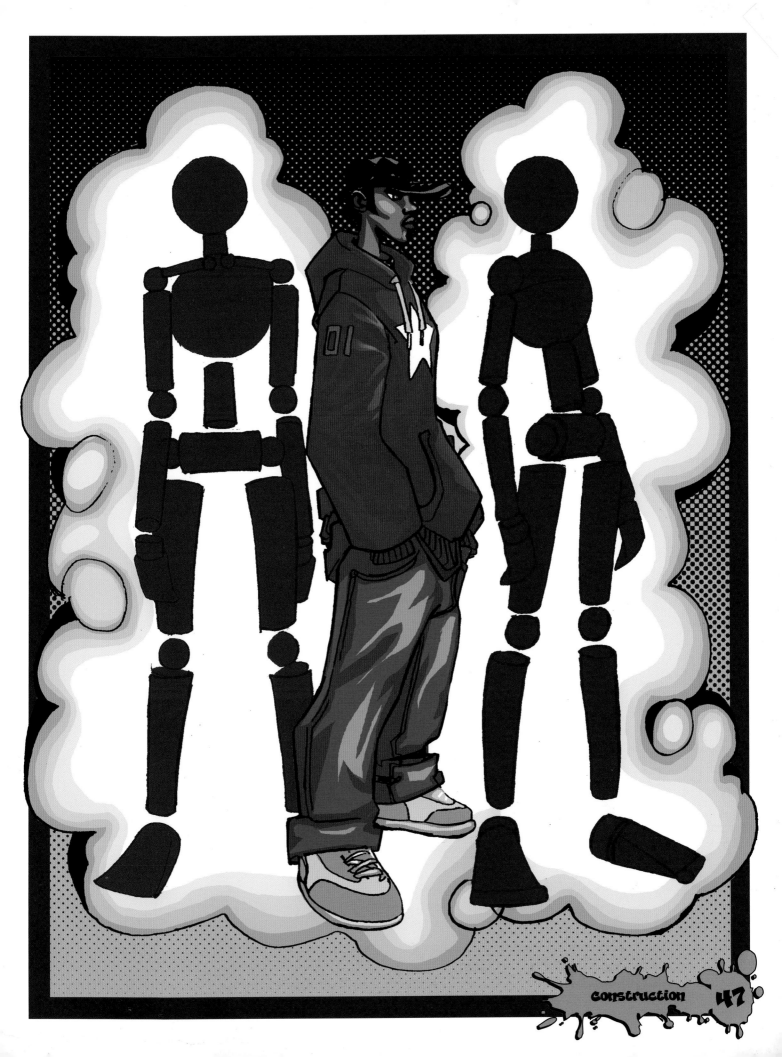

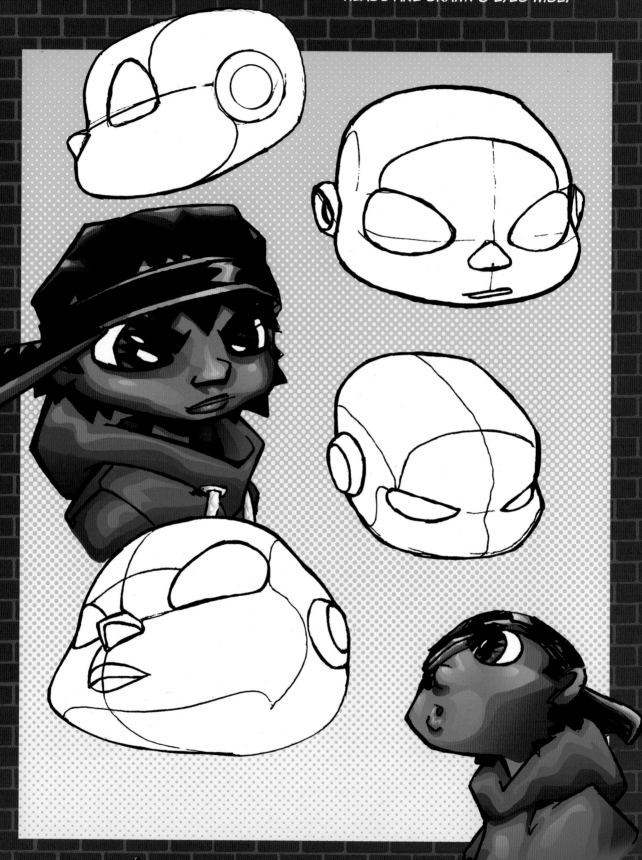

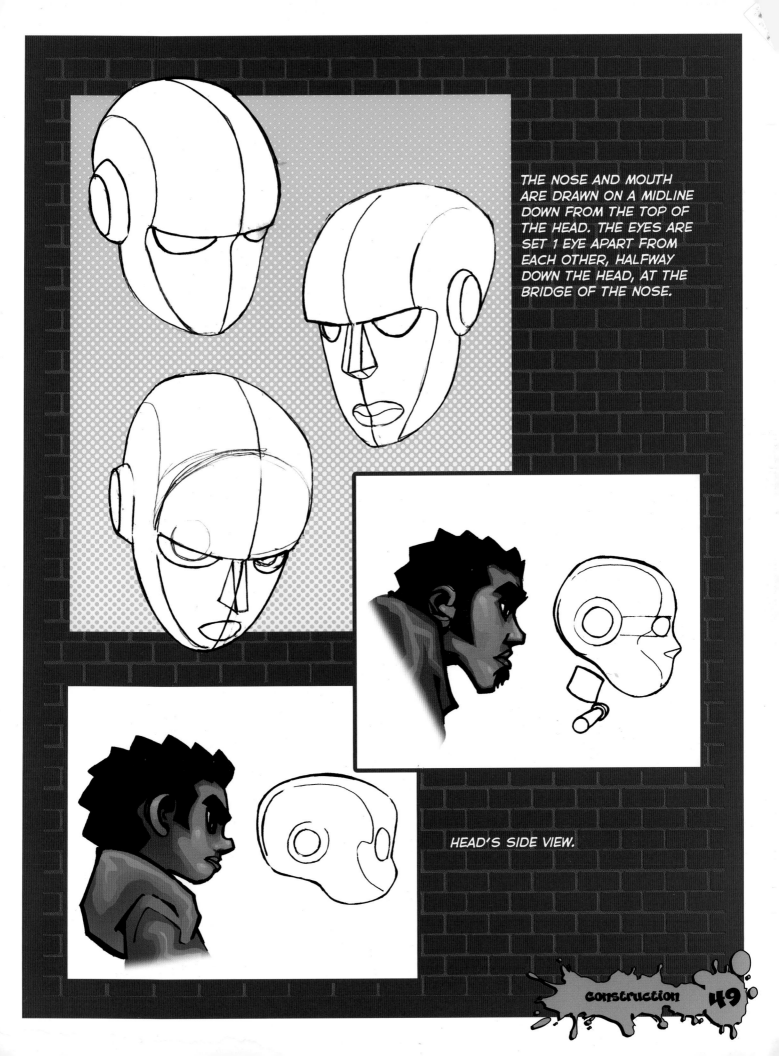

THE NOSE AND MOUTH ARE DRAWN ON A MIDLINE DOWN FROM THE TOP OF THE HEAD. THE EYES ARE SET 1 EYE APART FROM EACH OTHER, HALFWAY DOWN THE HEAD, AT THE BRIDGE OF THE NOSE.

HEAD'S SIDE VIEW.

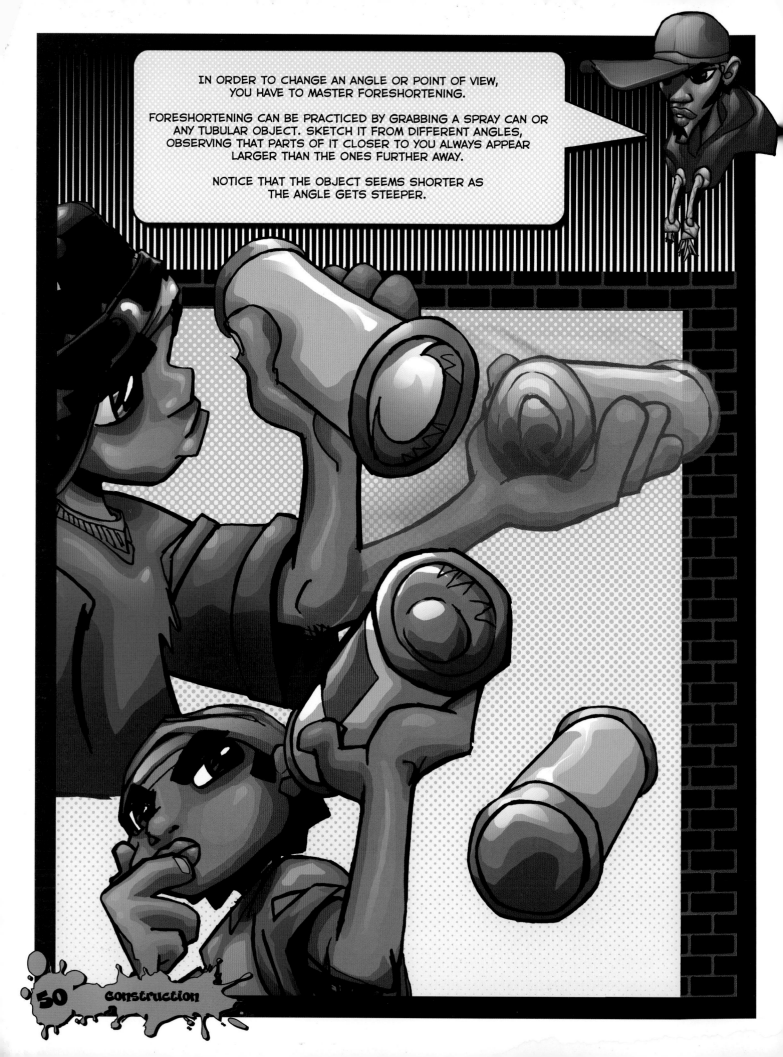

IN ORDER TO CHANGE AN ANGLE OR POINT OF VIEW,
YOU HAVE TO MASTER FORESHORTENING.

FORESHORTENING CAN BE PRACTICED BY GRABBING A SPRAY CAN OR
ANY TUBULAR OBJECT. SKETCH IT FROM DIFFERENT ANGLES,
OBSERVING THAT PARTS OF IT CLOSER TO YOU ALWAYS APPEAR
LARGER THAN THE ONES FURTHER AWAY.

NOTICE THAT THE OBJECT SEEMS SHORTER AS
THE ANGLE GETS STEEPER.

construction

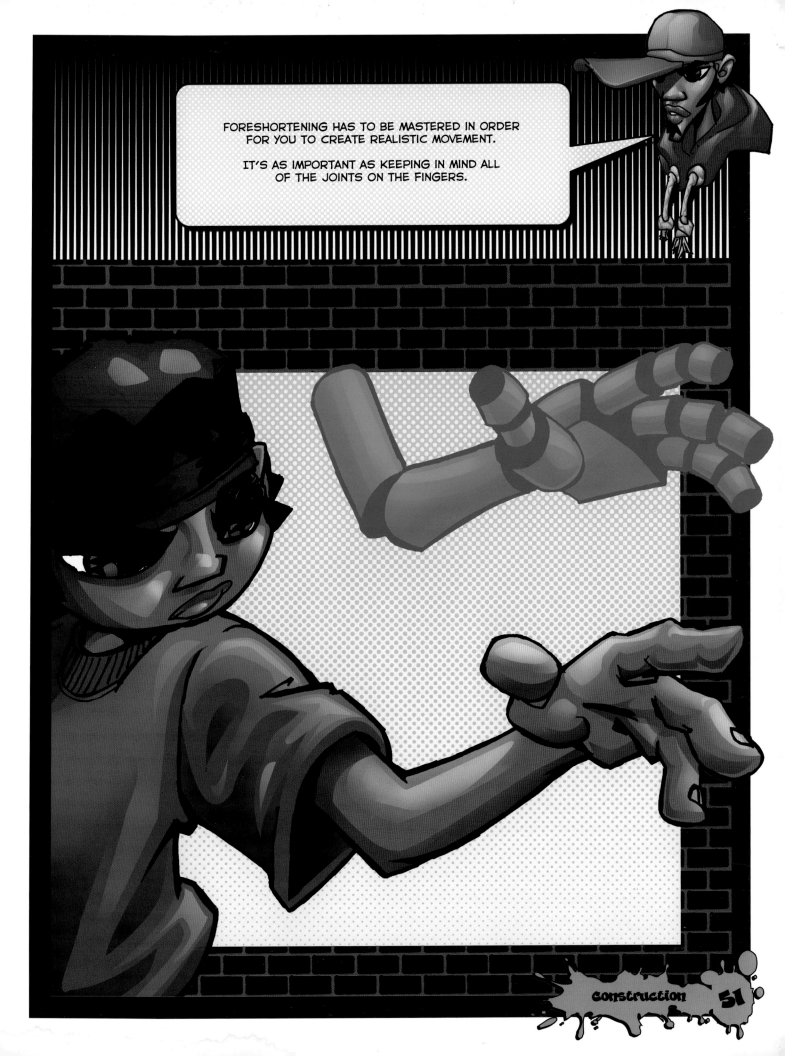

FORESHORTENING HAS TO BE MASTERED IN ORDER
FOR YOU TO CREATE REALISTIC MOVEMENT.

IT'S AS IMPORTANT AS KEEPING IN MIND ALL
OF THE JOINTS ON THE FINGERS.

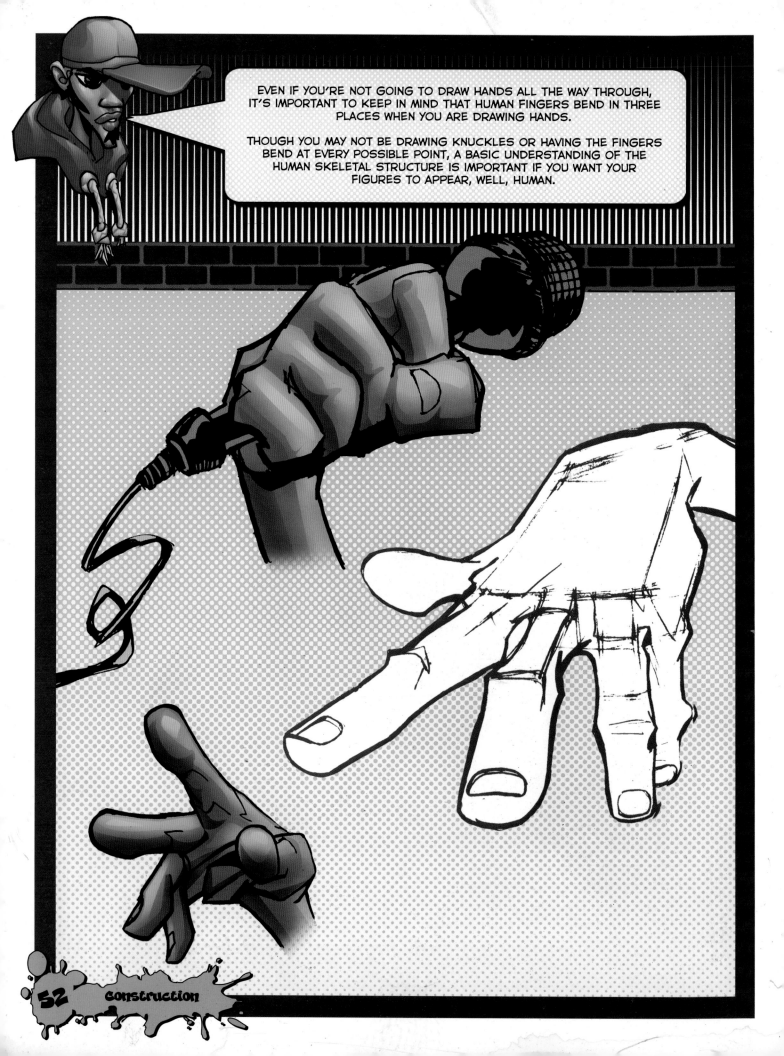

EVEN IF YOU'RE NOT GOING TO DRAW HANDS ALL THE WAY THROUGH, IT'S IMPORTANT TO KEEP IN MIND THAT HUMAN FINGERS BEND IN THREE PLACES WHEN YOU ARE DRAWING HANDS.

THOUGH YOU MAY NOT BE DRAWING KNUCKLES OR HAVING THE FINGERS BEND AT EVERY POSSIBLE POINT, A BASIC UNDERSTANDING OF THE HUMAN SKELETAL STRUCTURE IS IMPORTANT IF YOU WANT YOUR FIGURES TO APPEAR, WELL, HUMAN.

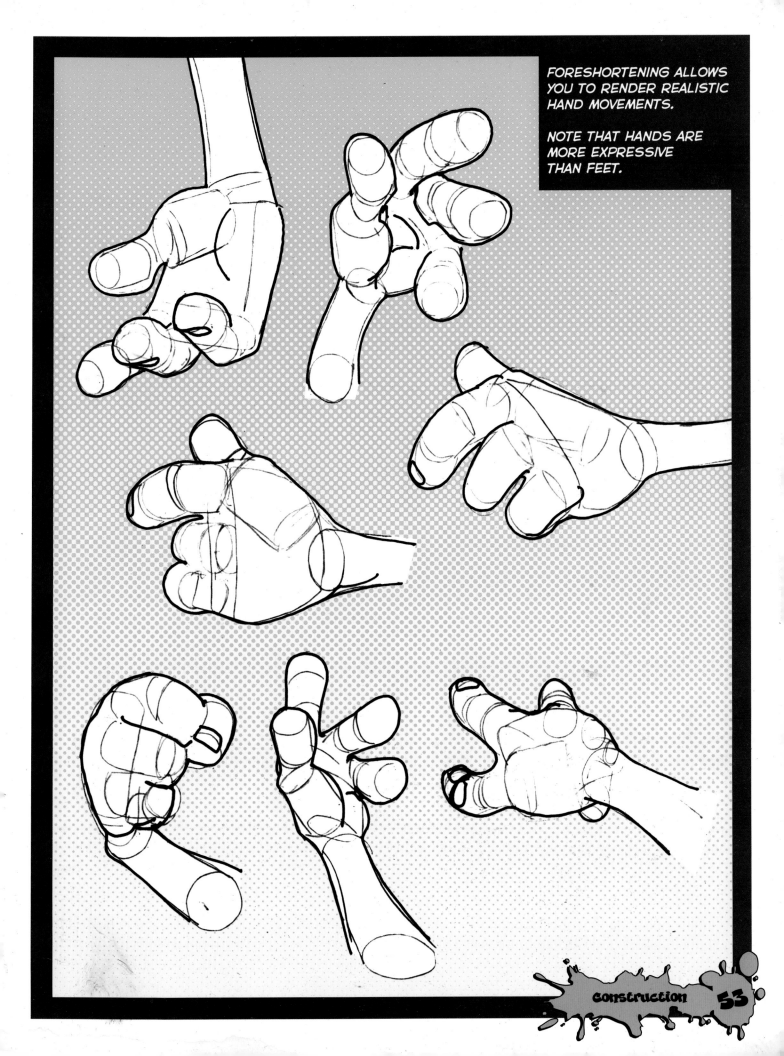

FORESHORTENING ALLOWS YOU TO RENDER REALISTIC HAND MOVEMENTS.

NOTE THAT HANDS ARE MORE EXPRESSIVE THAN FEET.

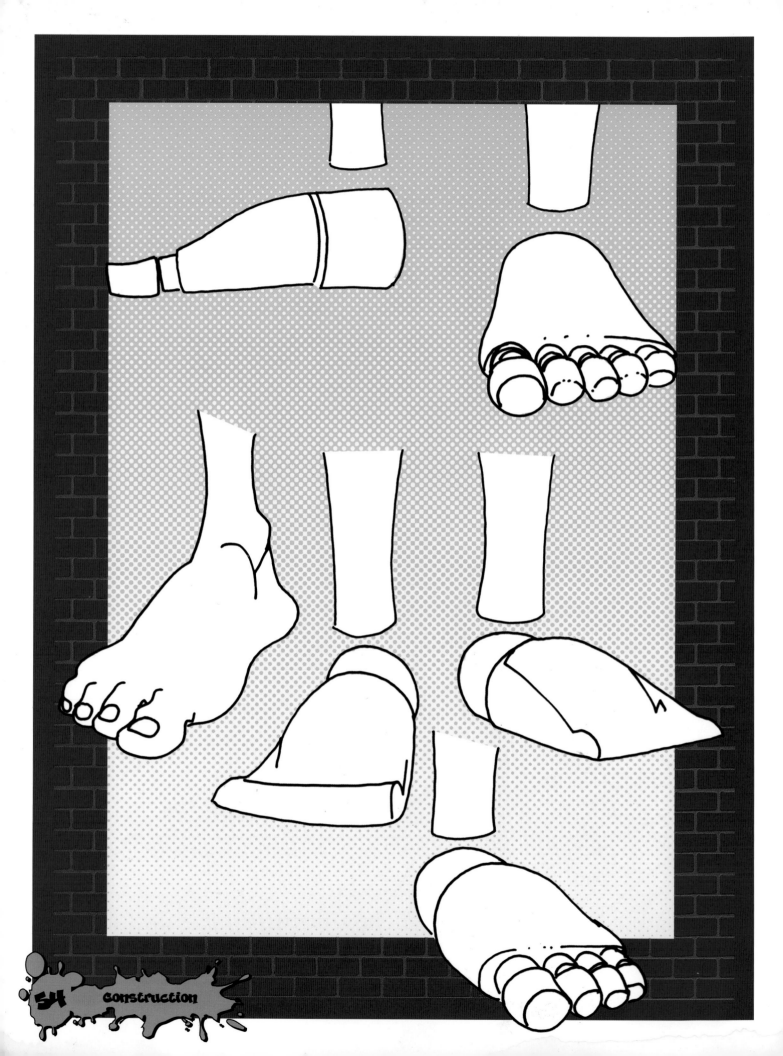

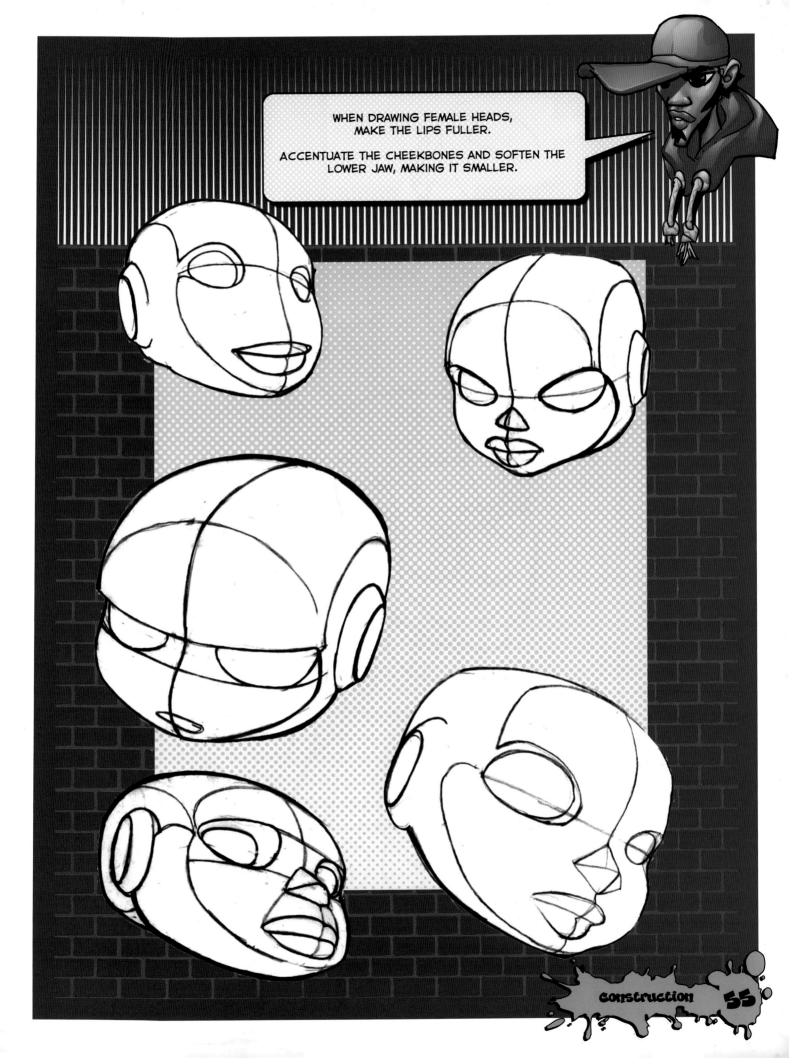

WHEN DRAWING FEMALE HEADS, MAKE THE LIPS FULLER.

ACCENTUATE THE CHEEKBONES AND SOFTEN THE LOWER JAW, MAKING IT SMALLER.

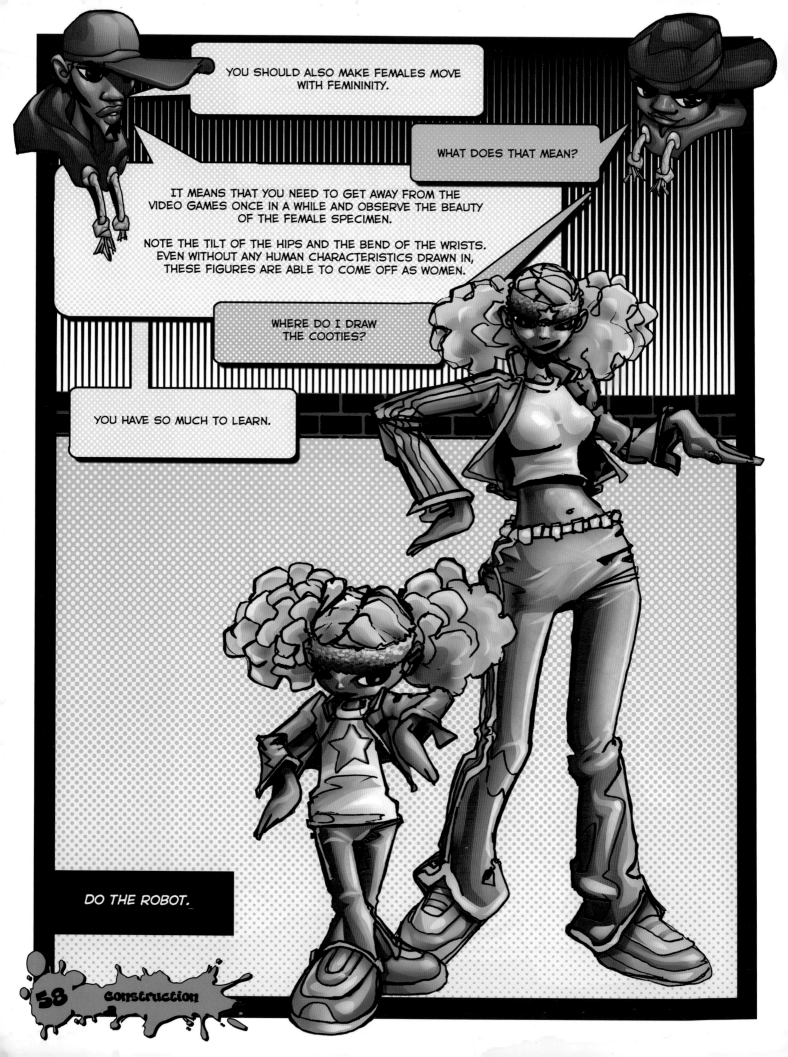

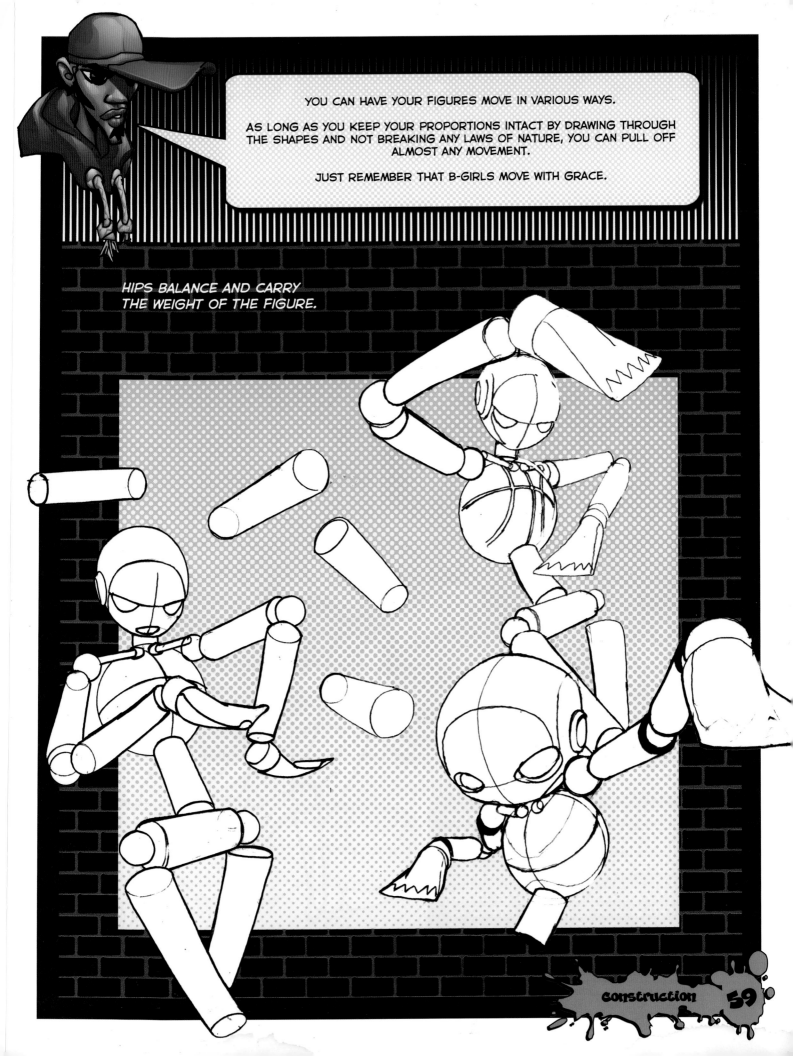

YOU CAN HAVE YOUR FIGURES MOVE IN VARIOUS WAYS.

AS LONG AS YOU KEEP YOUR PROPORTIONS INTACT BY DRAWING THROUGH THE SHAPES AND NOT BREAKING ANY LAWS OF NATURE, YOU CAN PULL OFF ALMOST ANY MOVEMENT.

JUST REMEMBER THAT B-GIRLS MOVE WITH GRACE.

HIPS BALANCE AND CARRY THE WEIGHT OF THE FIGURE.

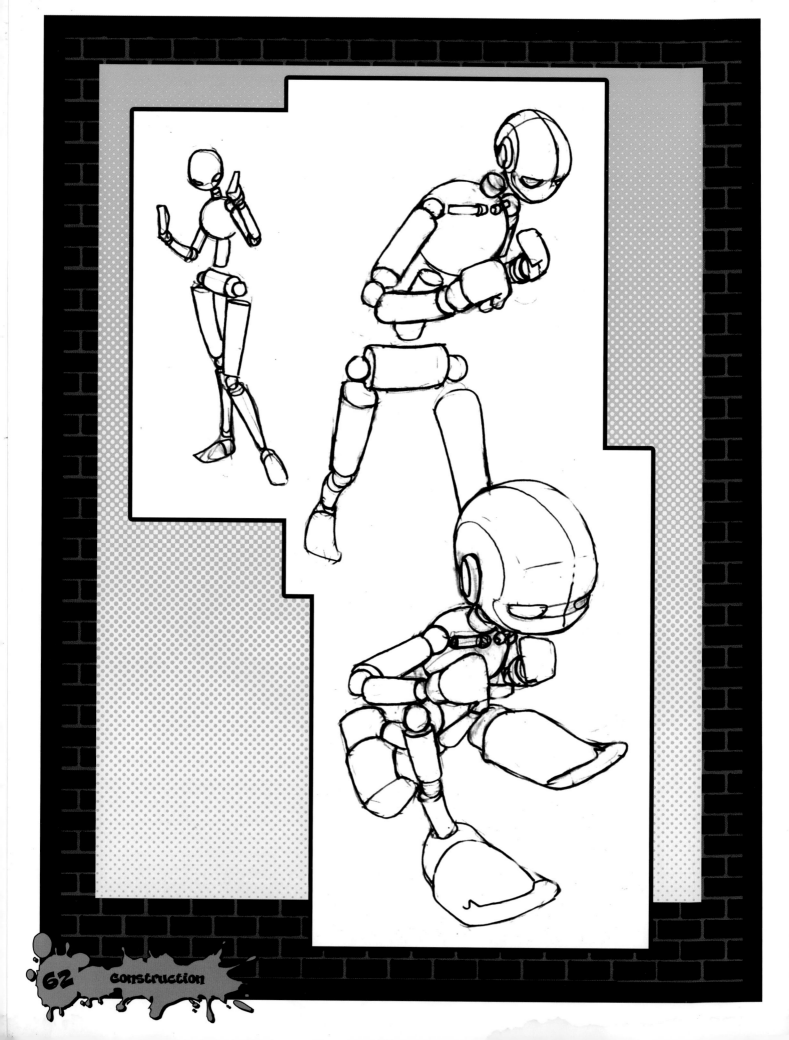

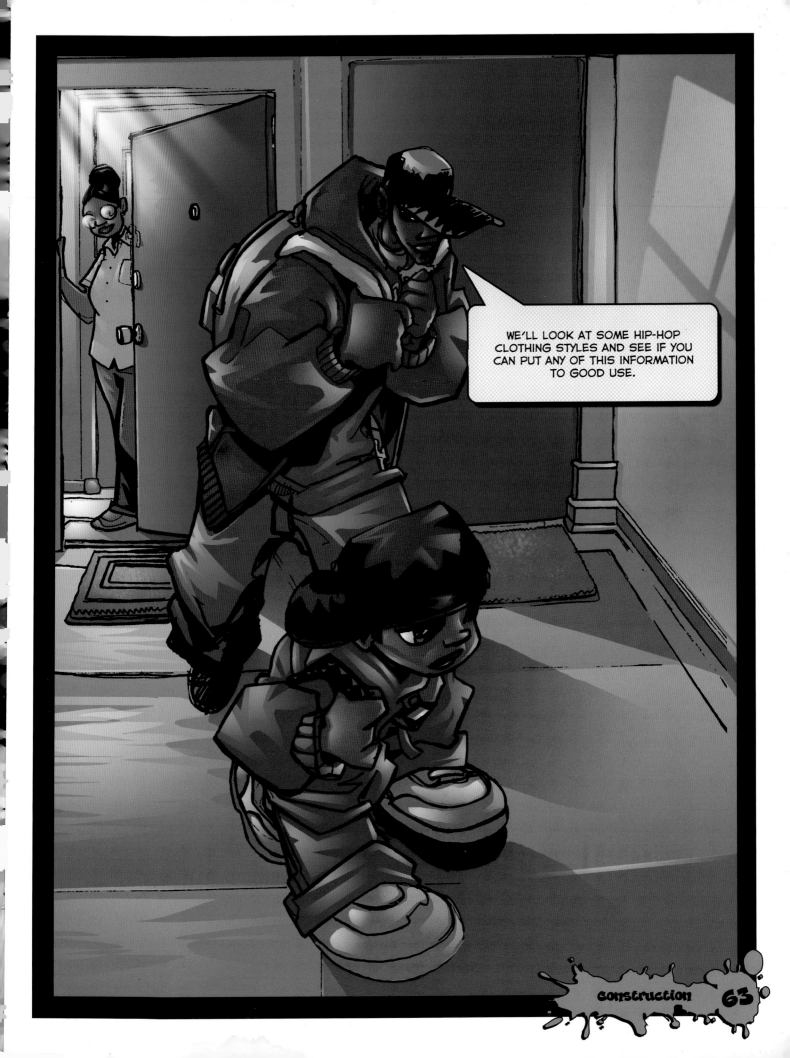

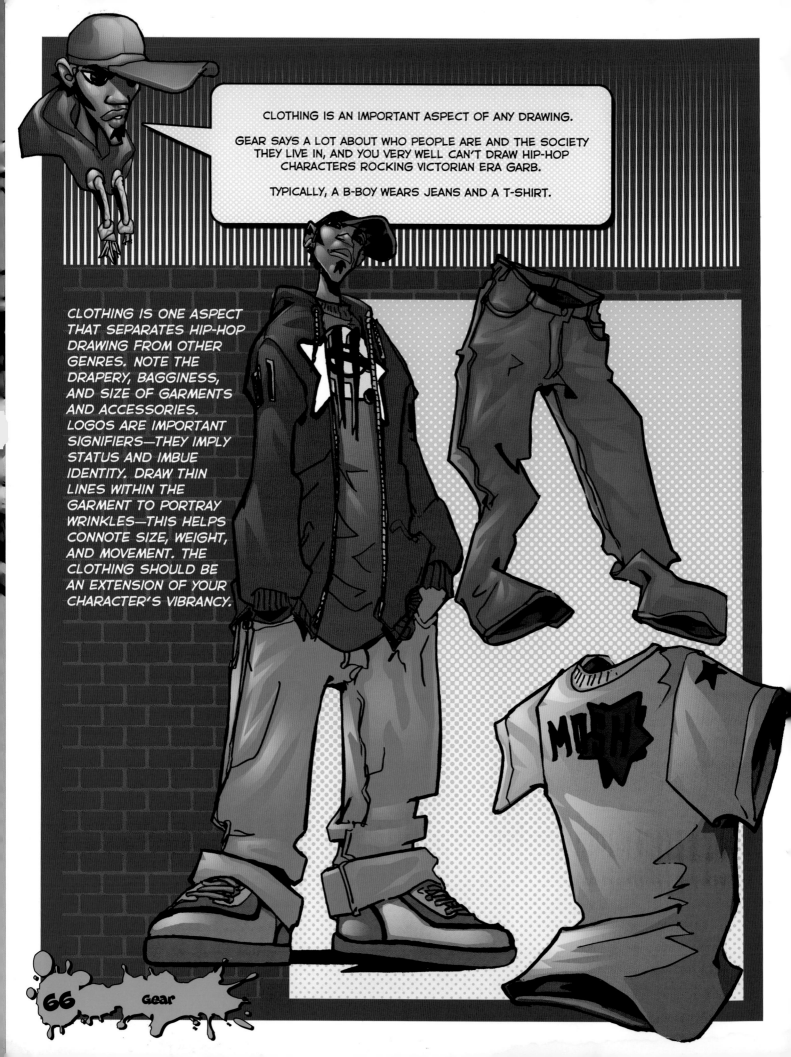

CLOTHING IS AN IMPORTANT ASPECT OF ANY DRAWING.

GEAR SAYS A LOT ABOUT WHO PEOPLE ARE AND THE SOCIETY THEY LIVE IN, AND YOU VERY WELL CAN'T DRAW HIP-HOP CHARACTERS ROCKING VICTORIAN ERA GARB.

TYPICALLY, A B-BOY WEARS JEANS AND A T-SHIRT.

CLOTHING IS ONE ASPECT THAT SEPARATES HIP-HOP DRAWING FROM OTHER GENRES. NOTE THE DRAPERY, BAGGINESS, AND SIZE OF GARMENTS AND ACCESSORIES. LOGOS ARE IMPORTANT SIGNIFIERS—THEY IMPLY STATUS AND IMBUE IDENTITY. DRAW THIN LINES WITHIN THE GARMENT TO PORTRAY WRINKLES—THIS HELPS CONNOTE SIZE, WEIGHT, AND MOVEMENT. THE CLOTHING SHOULD BE AN EXTENSION OF YOUR CHARACTER'S VIBRANCY.

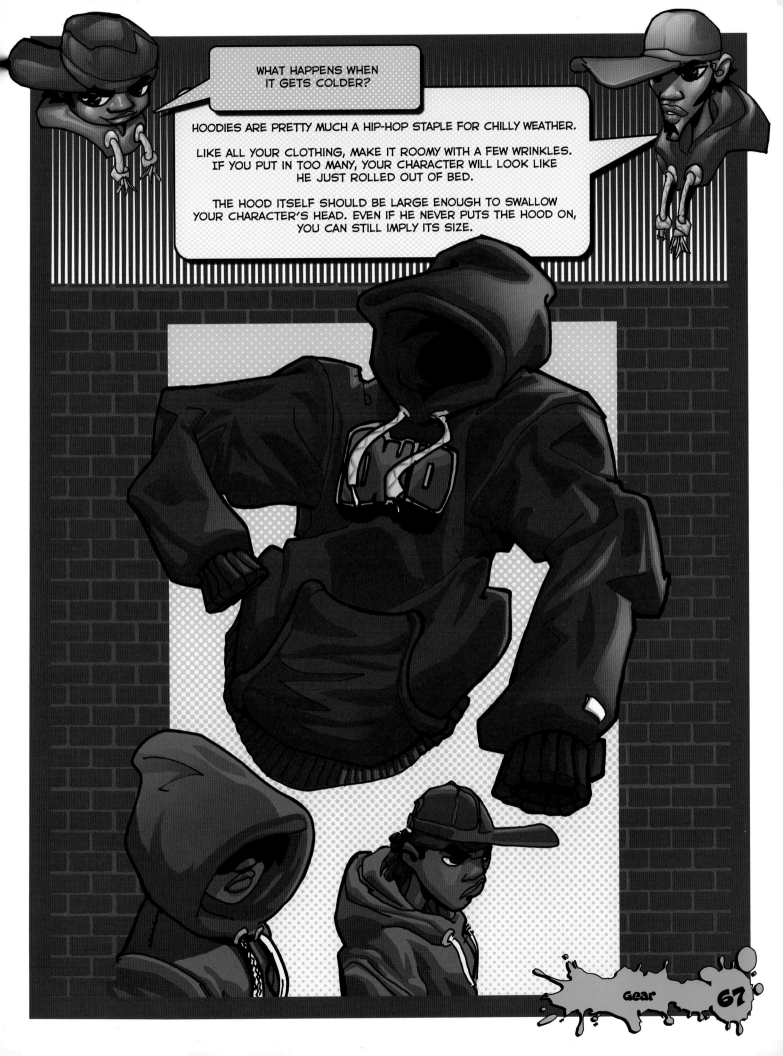

WHAT HAPPENS WHEN
IT GETS COLDER?

HOODIES ARE PRETTY MUCH A HIP-HOP STAPLE FOR CHILLY WEATHER.

LIKE ALL YOUR CLOTHING, MAKE IT ROOMY WITH A FEW WRINKLES.
IF YOU PUT IN TOO MANY, YOUR CHARACTER WILL LOOK LIKE
HE JUST ROLLED OUT OF BED.

THE HOOD ITSELF SHOULD BE LARGE ENOUGH TO SWALLOW
YOUR CHARACTER'S HEAD. EVEN IF HE NEVER PUTS THE HOOD ON,
YOU CAN STILL IMPLY ITS SIZE.

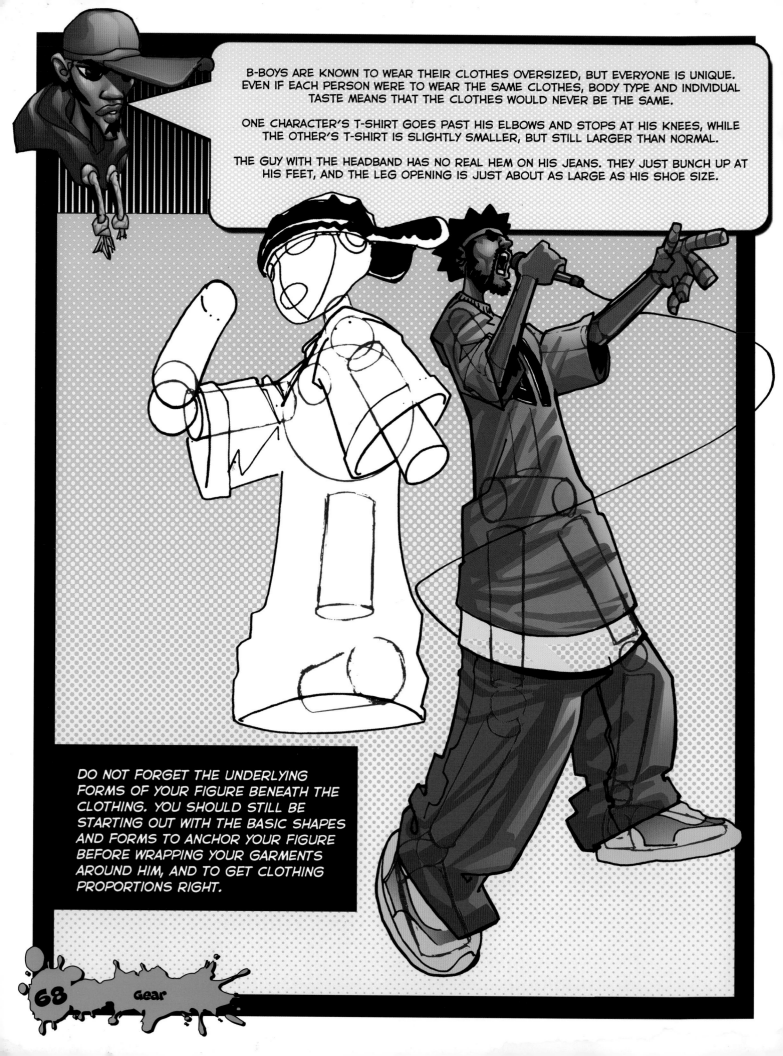

B-BOYS ARE KNOWN TO WEAR THEIR CLOTHES OVERSIZED, BUT EVERYONE IS UNIQUE. EVEN IF EACH PERSON WERE TO WEAR THE SAME CLOTHES, BODY TYPE AND INDIVIDUAL TASTE MEANS THAT THE CLOTHES WOULD NEVER BE THE SAME.

ONE CHARACTER'S T-SHIRT GOES PAST HIS ELBOWS AND STOPS AT HIS KNEES, WHILE THE OTHER'S T-SHIRT IS SLIGHTLY SMALLER, BUT STILL LARGER THAN NORMAL.

THE GUY WITH THE HEADBAND HAS NO REAL HEM ON HIS JEANS. THEY JUST BUNCH UP AT HIS FEET, AND THE LEG OPENING IS JUST ABOUT AS LARGE AS HIS SHOE SIZE.

DO NOT FORGET THE UNDERLYING FORMS OF YOUR FIGURE BENEATH THE CLOTHING. YOU SHOULD STILL BE STARTING OUT WITH THE BASIC SHAPES AND FORMS TO ANCHOR YOUR FIGURE BEFORE WRAPPING YOUR GARMENTS AROUND HIM, AND TO GET CLOTHING PROPORTIONS RIGHT.

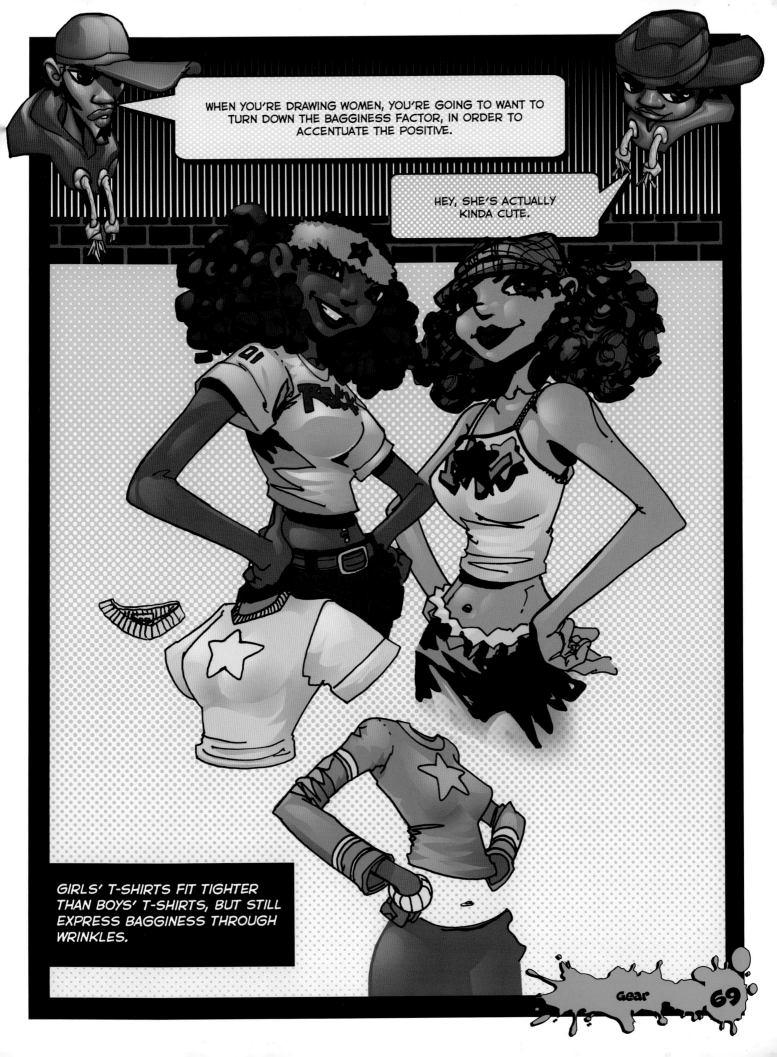

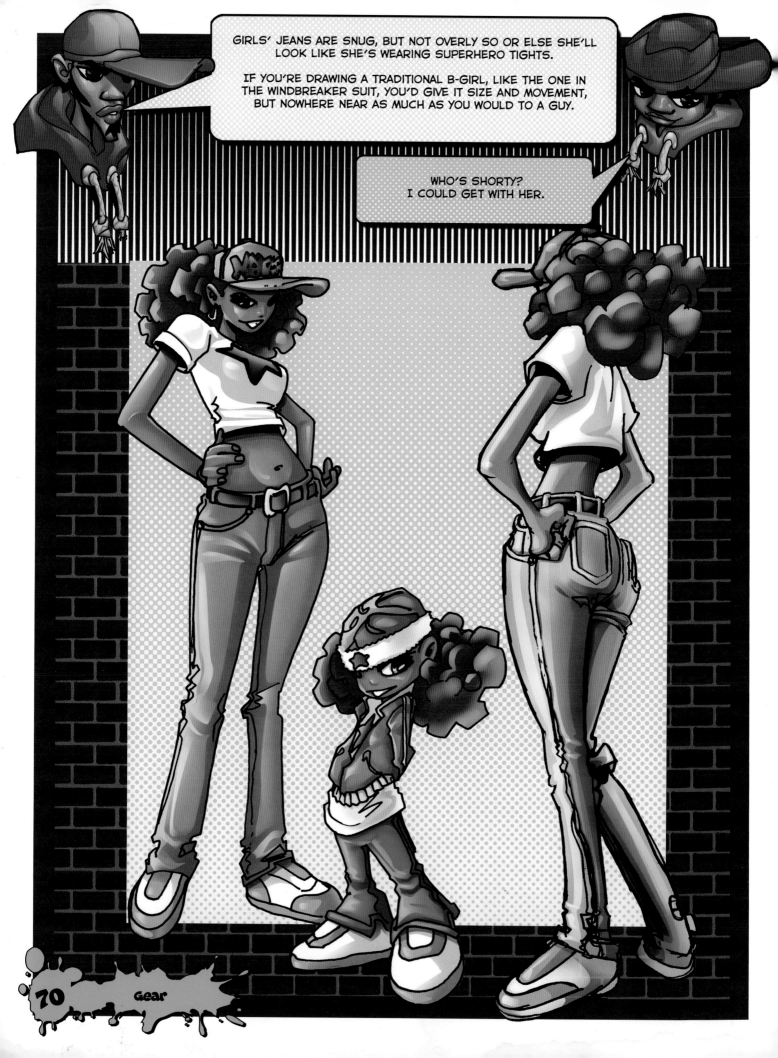

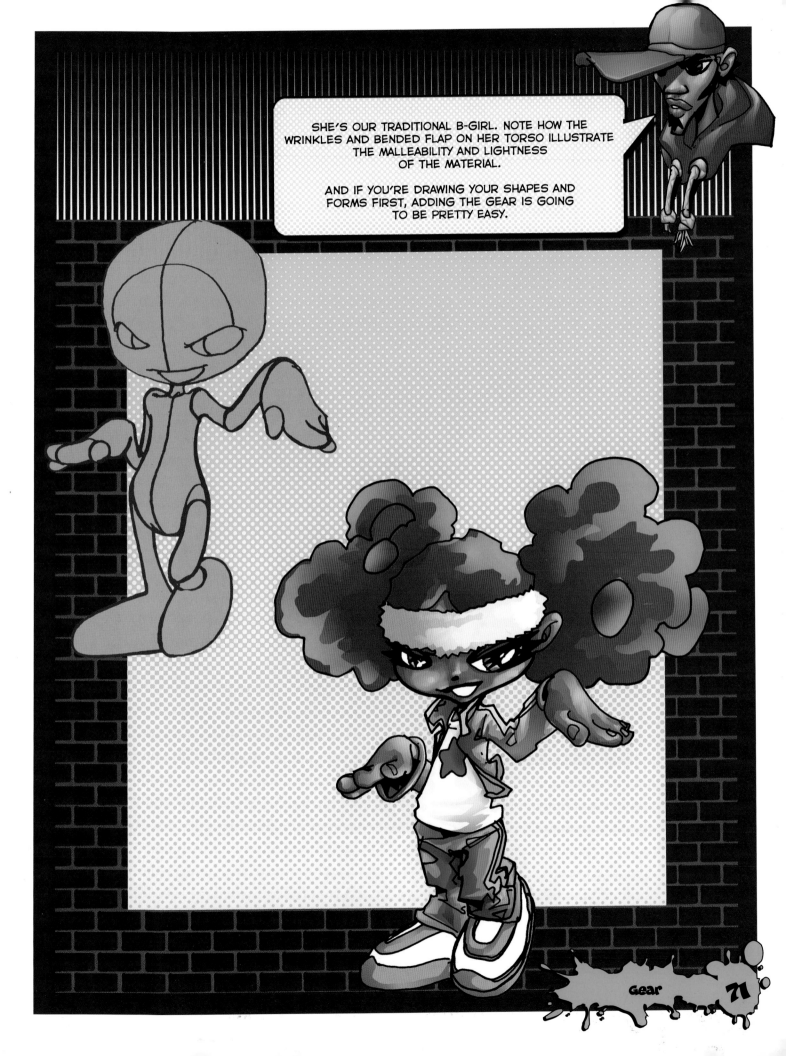

SHE'S OUR TRADITIONAL B-GIRL. NOTE HOW THE WRINKLES AND BENDED FLAP ON HER TORSO ILLUSTRATE THE MALLEABILITY AND LIGHTNESS OF THE MATERIAL.

AND IF YOU'RE DRAWING YOUR SHAPES AND FORMS FIRST, ADDING THE GEAR IS GOING TO BE PRETTY EASY.

Gear

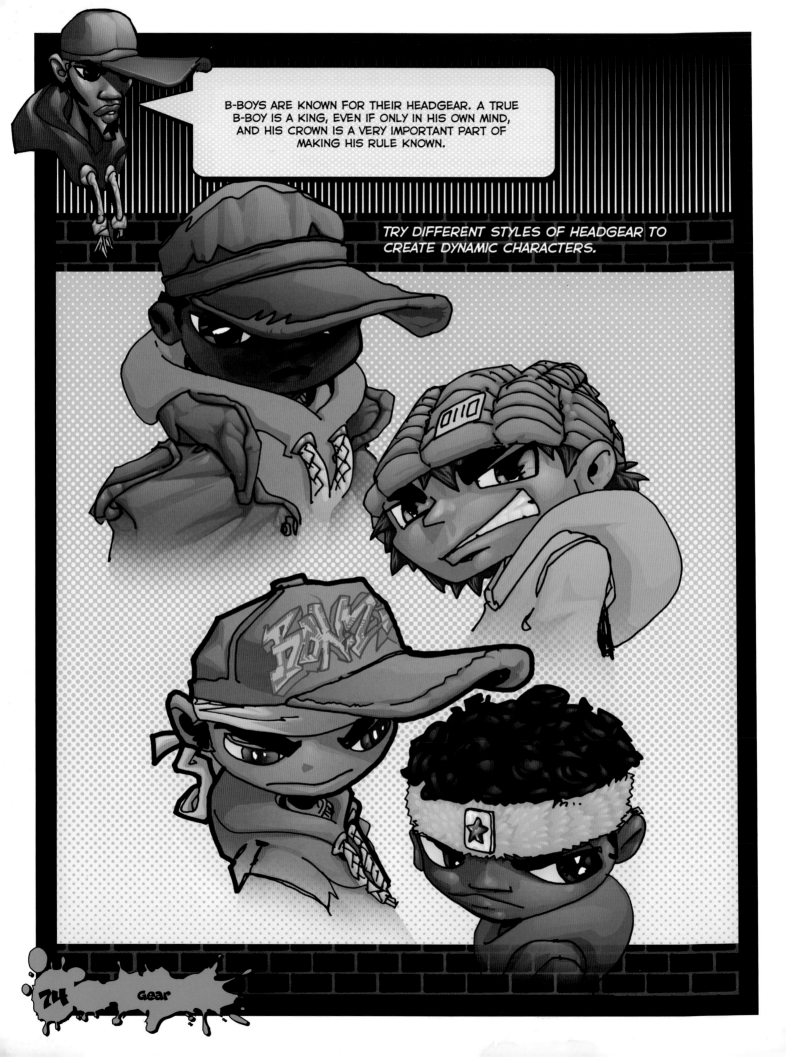

B-BOYS ARE KNOWN FOR THEIR HEADGEAR. A TRUE
B-BOY IS A KING, EVEN IF ONLY IN HIS OWN MIND,
AND HIS CROWN IS A VERY IMPORTANT PART OF
MAKING HIS RULE KNOWN.

TRY DIFFERENT STYLES OF HEADGEAR TO
CREATE DYNAMIC CHARACTERS.

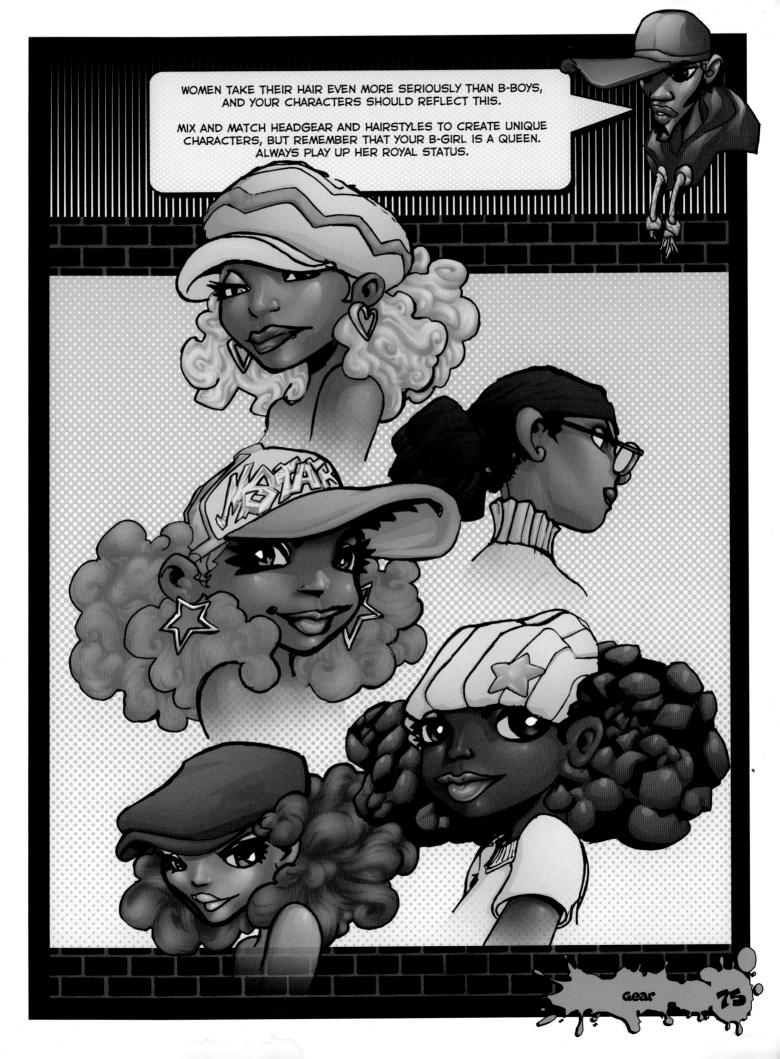

WOMEN TAKE THEIR HAIR EVEN MORE SERIOUSLY THAN B-BOYS, AND YOUR CHARACTERS SHOULD REFLECT THIS.

MIX AND MATCH HEADGEAR AND HAIRSTYLES TO CREATE UNIQUE CHARACTERS, BUT REMEMBER THAT YOUR B-GIRL IS A QUEEN. ALWAYS PLAY UP HER ROYAL STATUS.

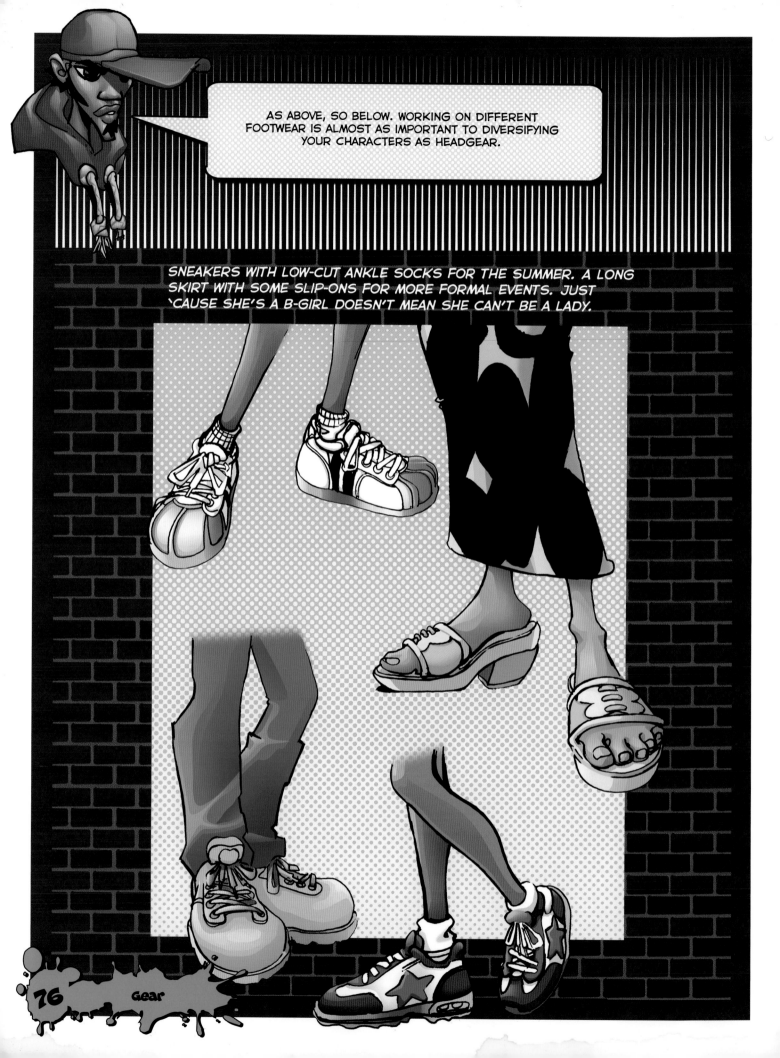

AS ABOVE, SO BELOW. WORKING ON DIFFERENT FOOTWEAR IS ALMOST AS IMPORTANT TO DIVERSIFYING YOUR CHARACTERS AS HEADGEAR.

SNEAKERS WITH LOW-CUT ANKLE SOCKS FOR THE SUMMER. A LONG SKIRT WITH SOME SLIP-ONS FOR MORE FORMAL EVENTS. JUST 'CAUSE SHE'S A B-GIRL DOESN'T MEAN SHE CAN'T BE A LADY.

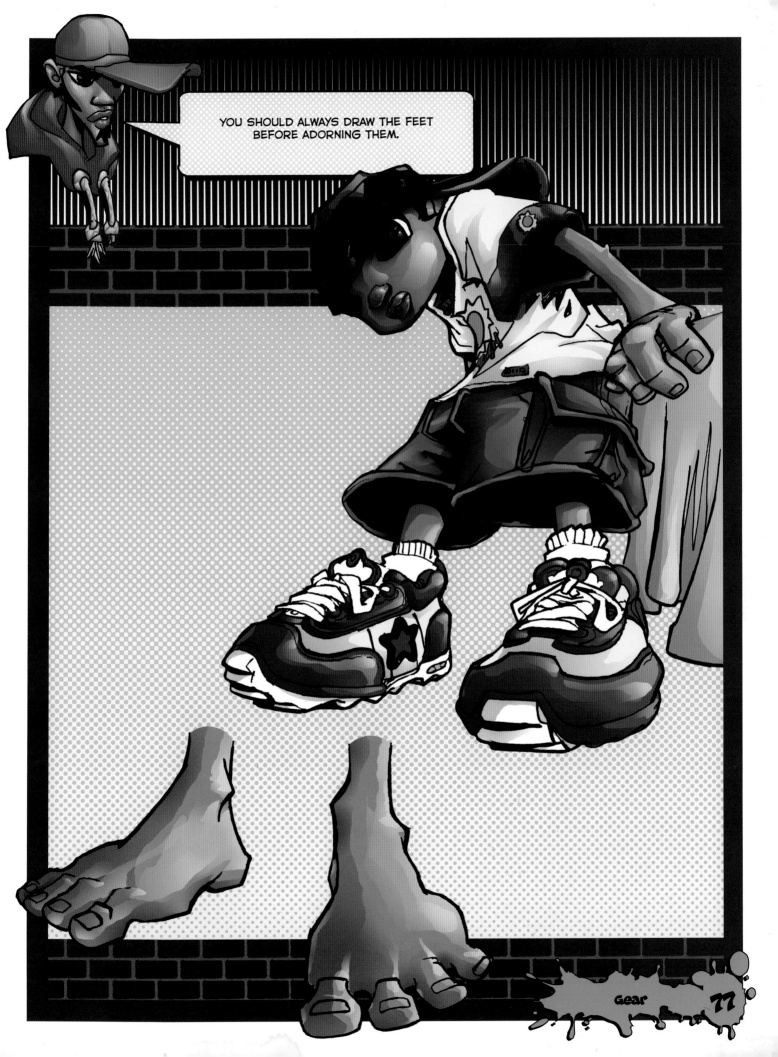

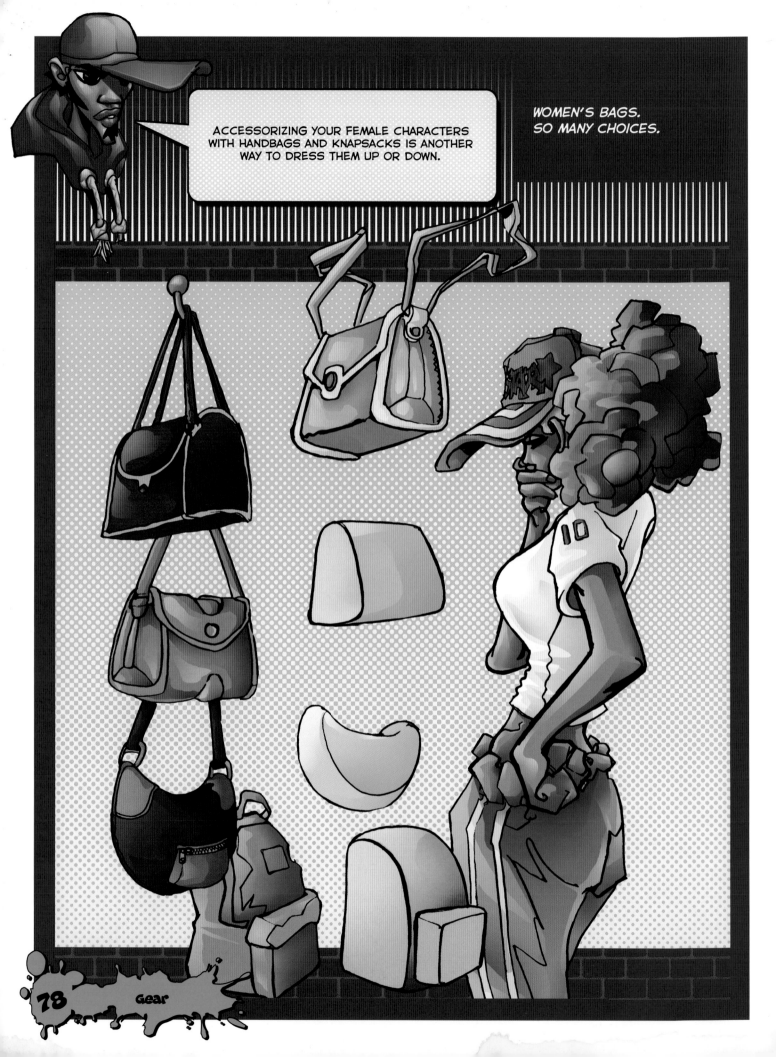

ACCESSORIZING YOUR FEMALE CHARACTERS WITH HANDBAGS AND KNAPSACKS IS ANOTHER WAY TO DRESS THEM UP OR DOWN.

WOMEN'S BAGS. SO MANY CHOICES.

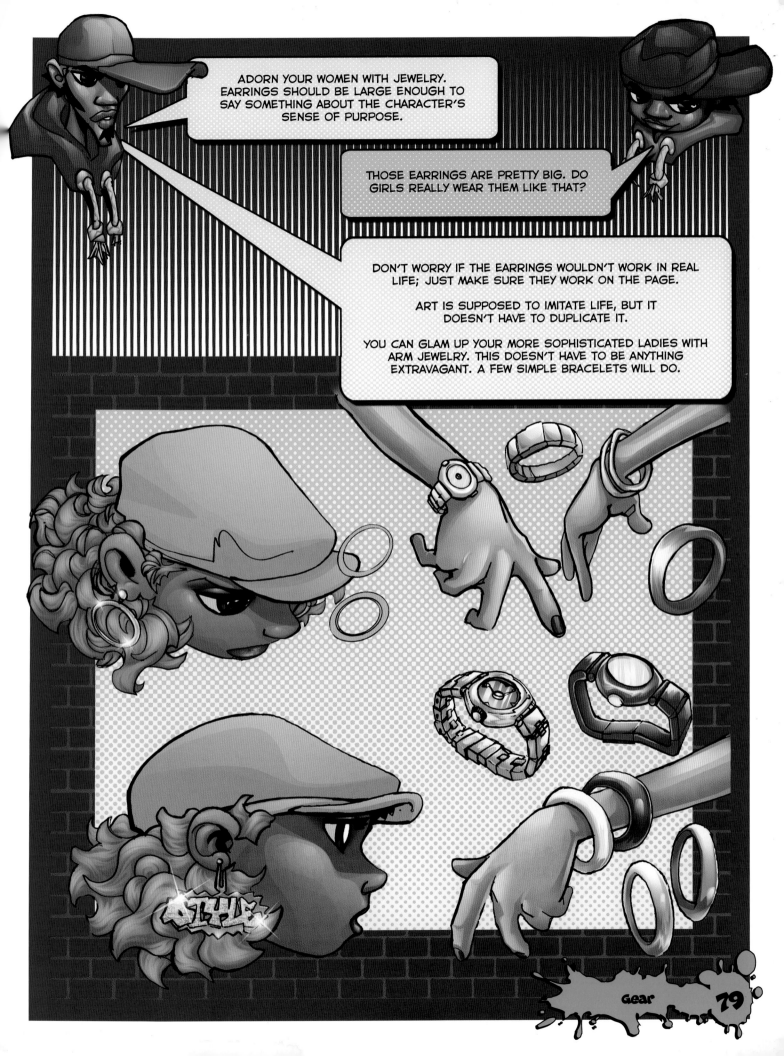

ADORN YOUR WOMEN WITH JEWELRY. EARRINGS SHOULD BE LARGE ENOUGH TO SAY SOMETHING ABOUT THE CHARACTER'S SENSE OF PURPOSE.

THOSE EARRINGS ARE PRETTY BIG. DO GIRLS REALLY WEAR THEM LIKE THAT?

DON'T WORRY IF THE EARRINGS WOULDN'T WORK IN REAL LIFE; JUST MAKE SURE THEY WORK ON THE PAGE.

ART IS SUPPOSED TO IMITATE LIFE, BUT IT DOESN'T HAVE TO DUPLICATE IT.

YOU CAN GLAM UP YOUR MORE SOPHISTICATED LADIES WITH ARM JEWELRY. THIS DOESN'T HAVE TO BE ANYTHING EXTRAVAGANT. A FEW SIMPLE BRACELETS WILL DO.

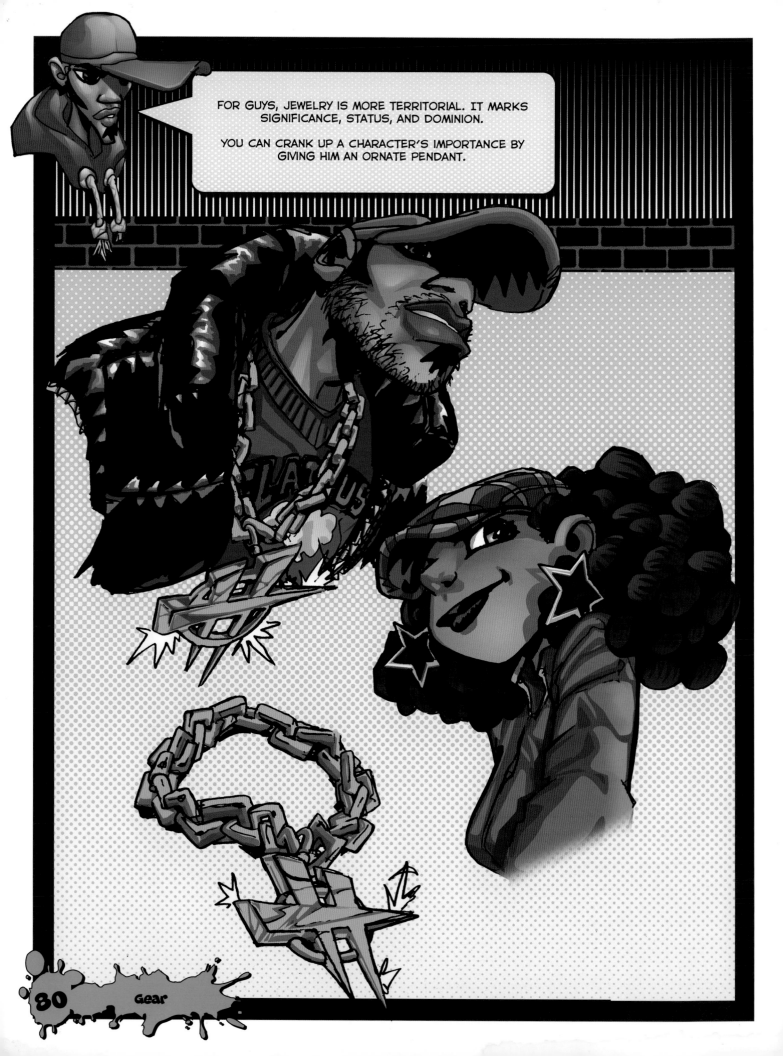

FOR GUYS, JEWELRY IS MORE TERRITORIAL. IT MARKS SIGNIFICANCE, STATUS, AND DOMINION.

YOU CAN CRANK UP A CHARACTER'S IMPORTANCE BY GIVING HIM AN ORNATE PENDANT.

posture and

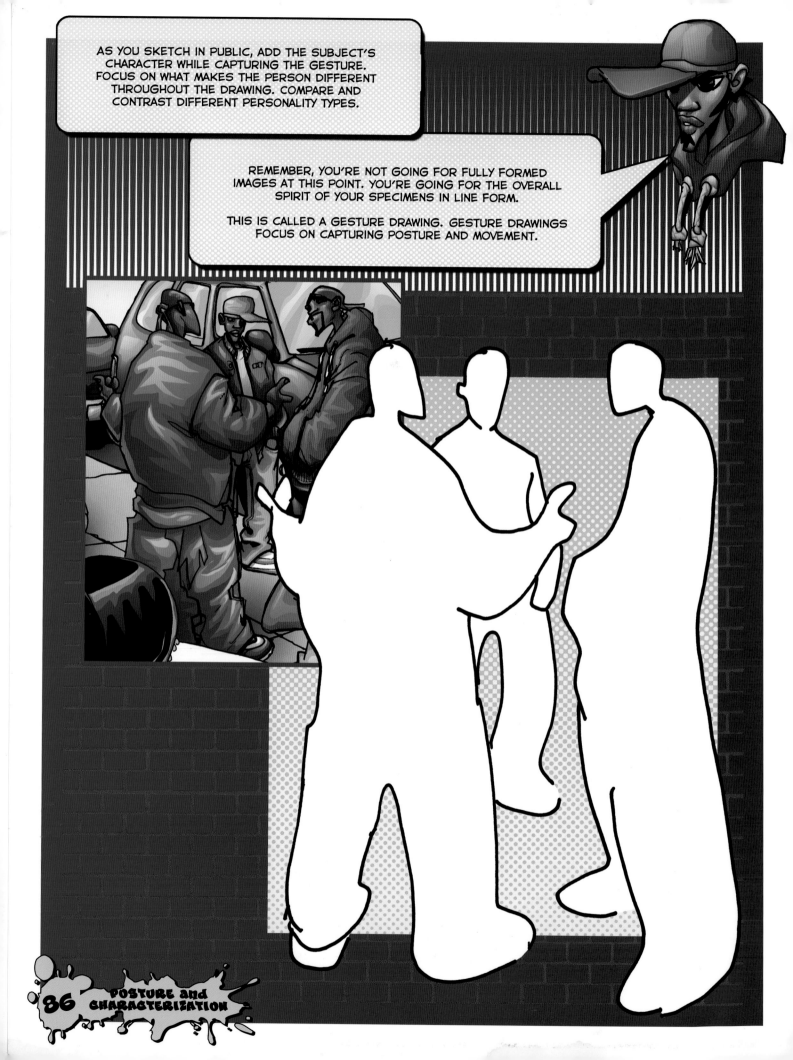

AS YOU SKETCH IN PUBLIC, ADD THE SUBJECT'S CHARACTER WHILE CAPTURING THE GESTURE. FOCUS ON WHAT MAKES THE PERSON DIFFERENT THROUGHOUT THE DRAWING. COMPARE AND CONTRAST DIFFERENT PERSONALITY TYPES.

REMEMBER, YOU'RE NOT GOING FOR FULLY FORMED IMAGES AT THIS POINT. YOU'RE GOING FOR THE OVERALL SPIRIT OF YOUR SPECIMENS IN LINE FORM.

THIS IS CALLED A GESTURE DRAWING. GESTURE DRAWINGS FOCUS ON CAPTURING POSTURE AND MOVEMENT.

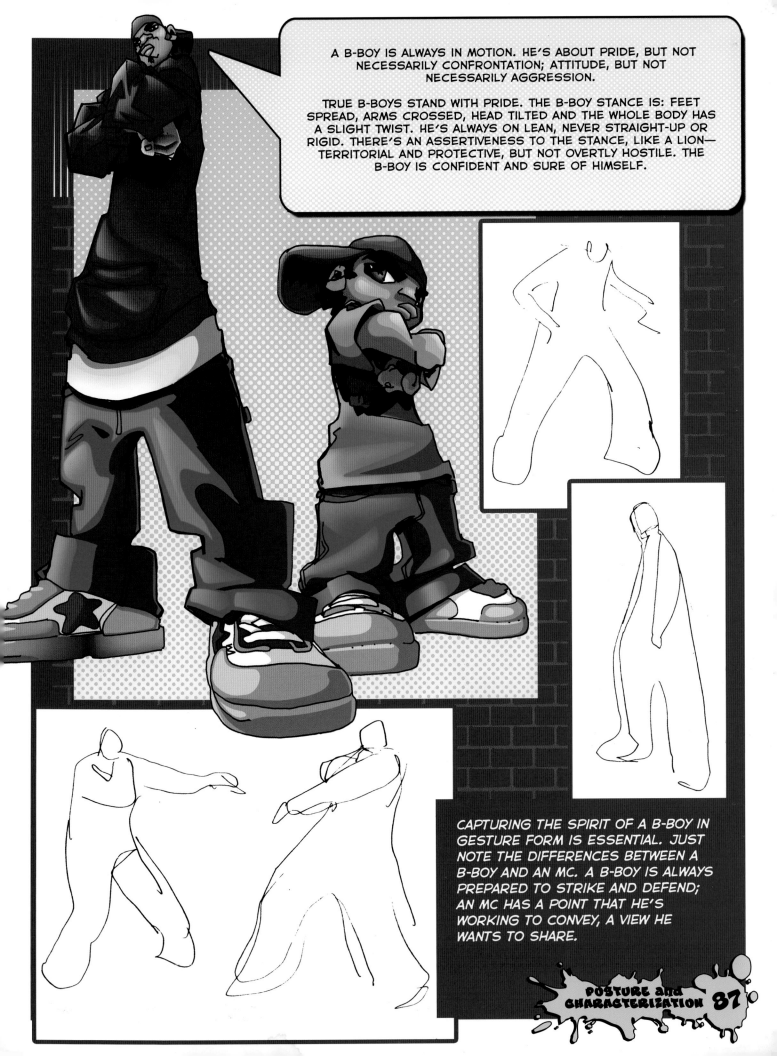

A B-BOY IS ALWAYS IN MOTION. HE'S ABOUT PRIDE, BUT NOT NECESSARILY CONFRONTATION; ATTITUDE, BUT NOT NECESSARILY AGGRESSION.

TRUE B-BOYS STAND WITH PRIDE. THE B-BOY STANCE IS: FEET SPREAD, ARMS CROSSED, HEAD TILTED AND THE WHOLE BODY HAS A SLIGHT TWIST. HE'S ALWAYS ON LEAN, NEVER STRAIGHT-UP OR RIGID. THERE'S AN ASSERTIVENESS TO THE STANCE, LIKE A LION—TERRITORIAL AND PROTECTIVE, BUT NOT OVERTLY HOSTILE. THE B-BOY IS CONFIDENT AND SURE OF HIMSELF.

CAPTURING THE SPIRIT OF A B-BOY IN GESTURE FORM IS ESSENTIAL. JUST NOTE THE DIFFERENCES BETWEEN A B-BOY AND AN MC. A B-BOY IS ALWAYS PREPARED TO STRIKE AND DEFEND; AN MC HAS A POINT THAT HE'S WORKING TO CONVEY, A VIEW HE WANTS TO SHARE.

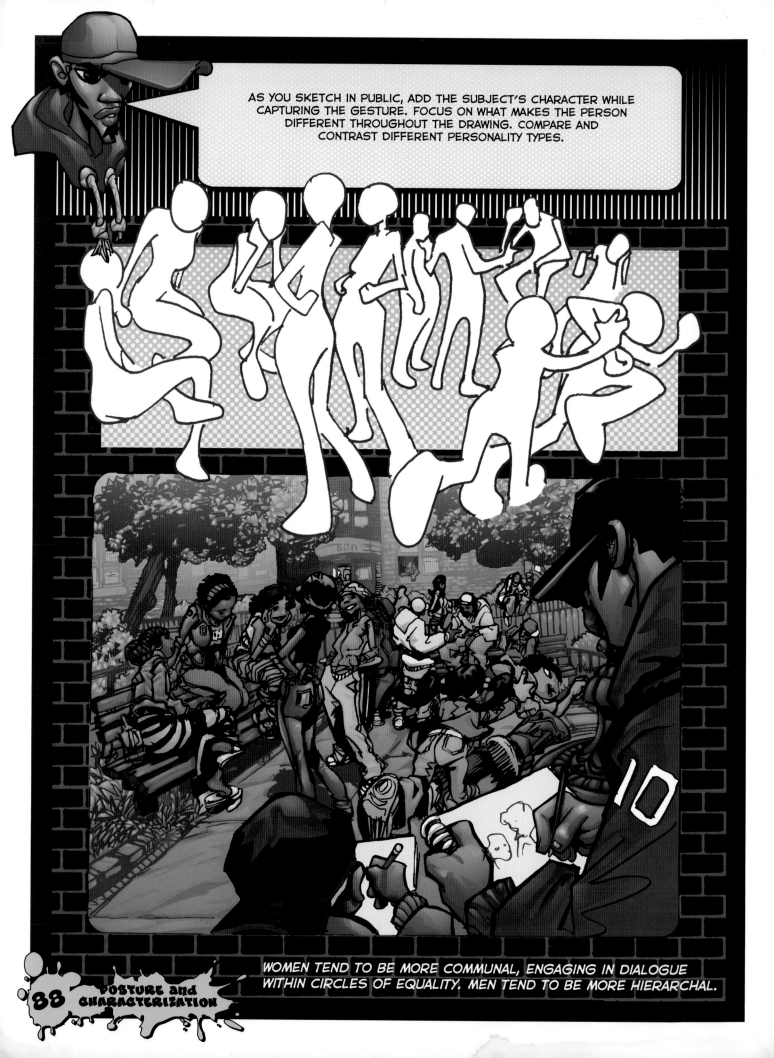

AS YOU SKETCH IN PUBLIC, ADD THE SUBJECT'S CHARACTER WHILE CAPTURING THE GESTURE. FOCUS ON WHAT MAKES THE PERSON DIFFERENT THROUGHOUT THE DRAWING. COMPARE AND CONTRAST DIFFERENT PERSONALITY TYPES.

WOMEN TEND TO BE MORE COMMUNAL, ENGAGING IN DIALOGUE WITHIN CIRCLES OF EQUALITY. MEN TEND TO BE MORE HIERARCHAL.

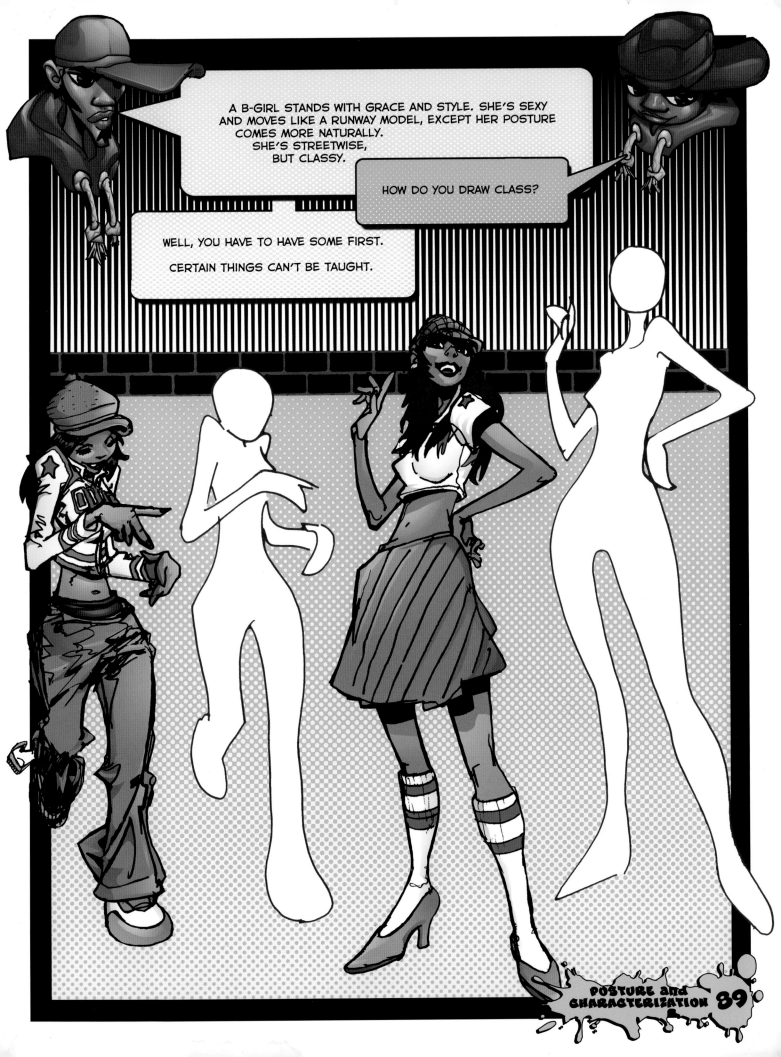

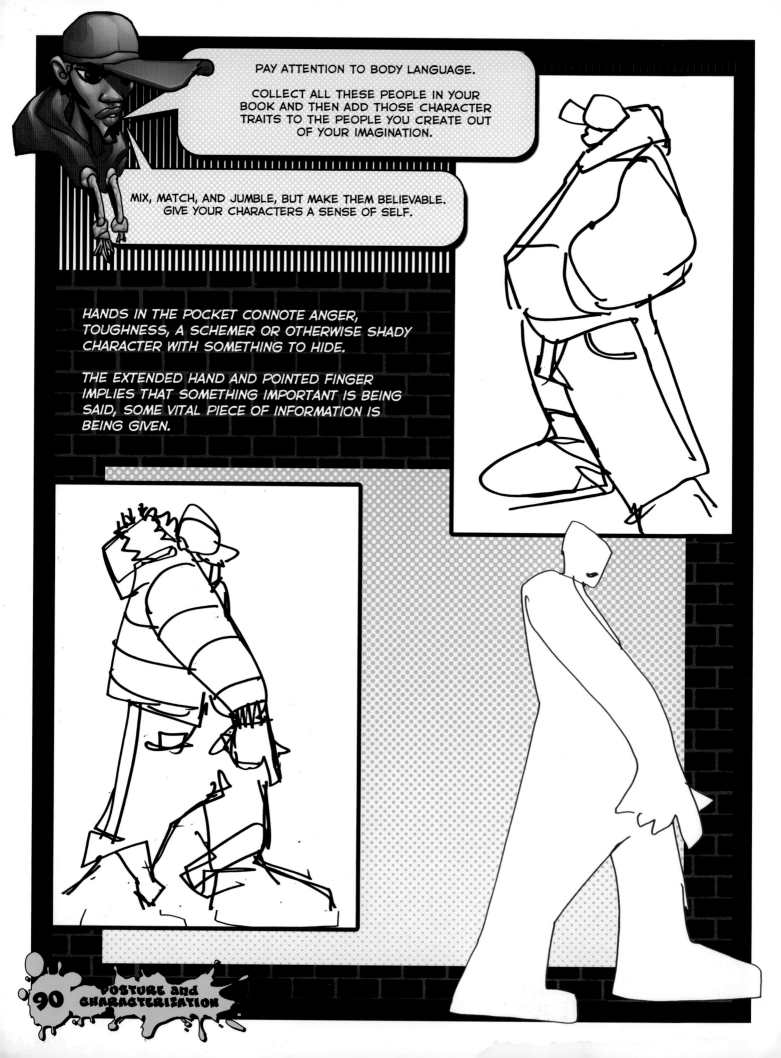

PAY ATTENTION TO BODY LANGUAGE.

COLLECT ALL THESE PEOPLE IN YOUR BOOK AND THEN ADD THOSE CHARACTER TRAITS TO THE PEOPLE YOU CREATE OUT OF YOUR IMAGINATION.

MIX, MATCH, AND JUMBLE, BUT MAKE THEM BELIEVABLE. GIVE YOUR CHARACTERS A SENSE OF SELF.

HANDS IN THE POCKET CONNOTE ANGER, TOUGHNESS, A SCHEMER OR OTHERWISE SHADY CHARACTER WITH SOMETHING TO HIDE.

THE EXTENDED HAND AND POINTED FINGER IMPLIES THAT SOMETHING IMPORTANT IS BEING SAID, SOME VITAL PIECE OF INFORMATION IS BEING GIVEN.

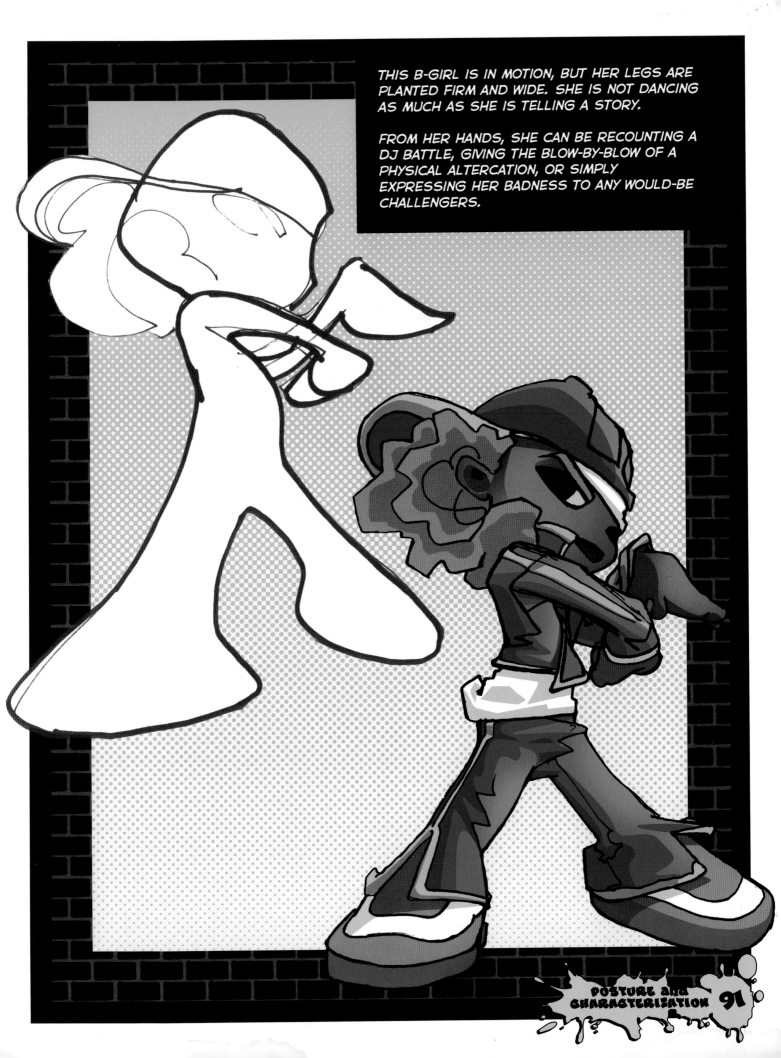

THIS B-GIRL IS IN MOTION, BUT HER LEGS ARE PLANTED FIRM AND WIDE. SHE IS NOT DANCING AS MUCH AS SHE IS TELLING A STORY.

FROM HER HANDS, SHE CAN BE RECOUNTING A DJ BATTLE, GIVING THE BLOW-BY-BLOW OF A PHYSICAL ALTERCATION, OR SIMPLY EXPRESSING HER BADNESS TO ANY WOULD-BE CHALLENGERS.

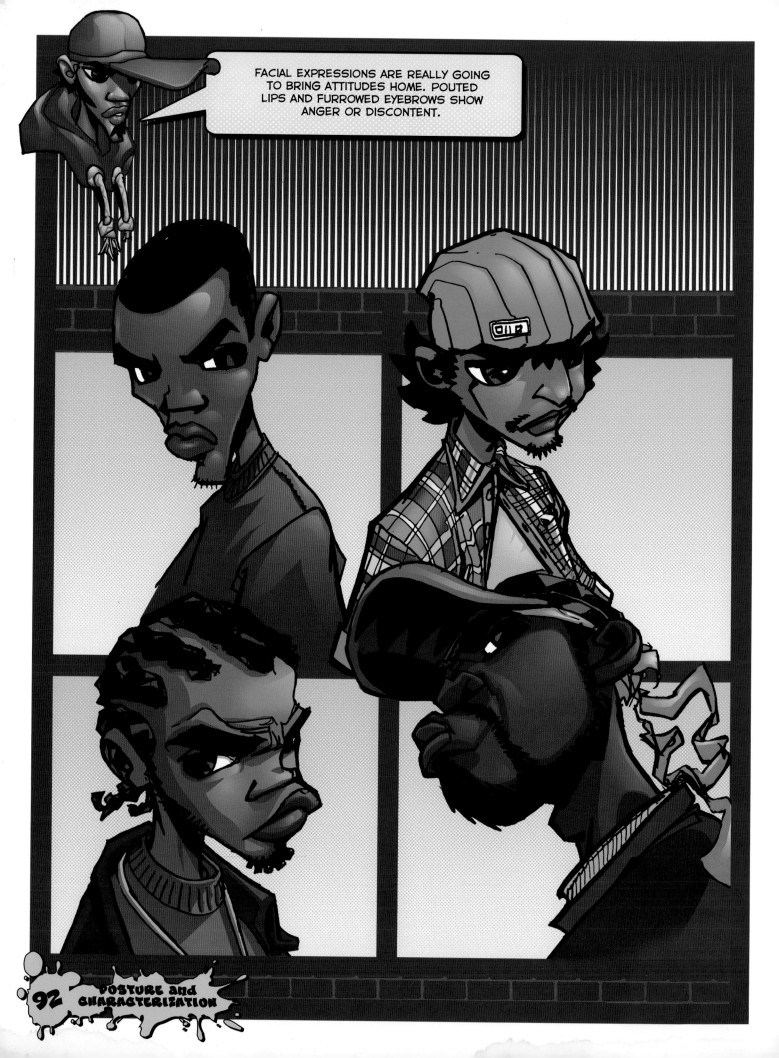

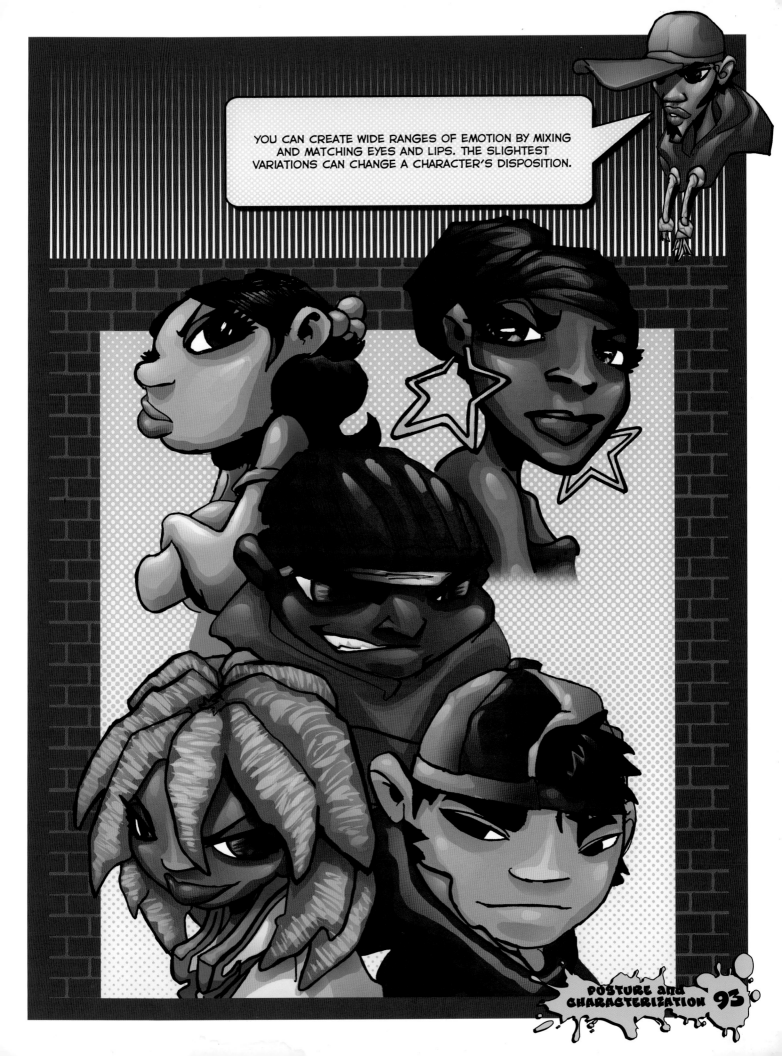

YOU CAN CREATE WIDE RANGES OF EMOTION BY MIXING AND MATCHING EYES AND LIPS. THE SLIGHTEST VARIATIONS CAN CHANGE A CHARACTER'S DISPOSITION.

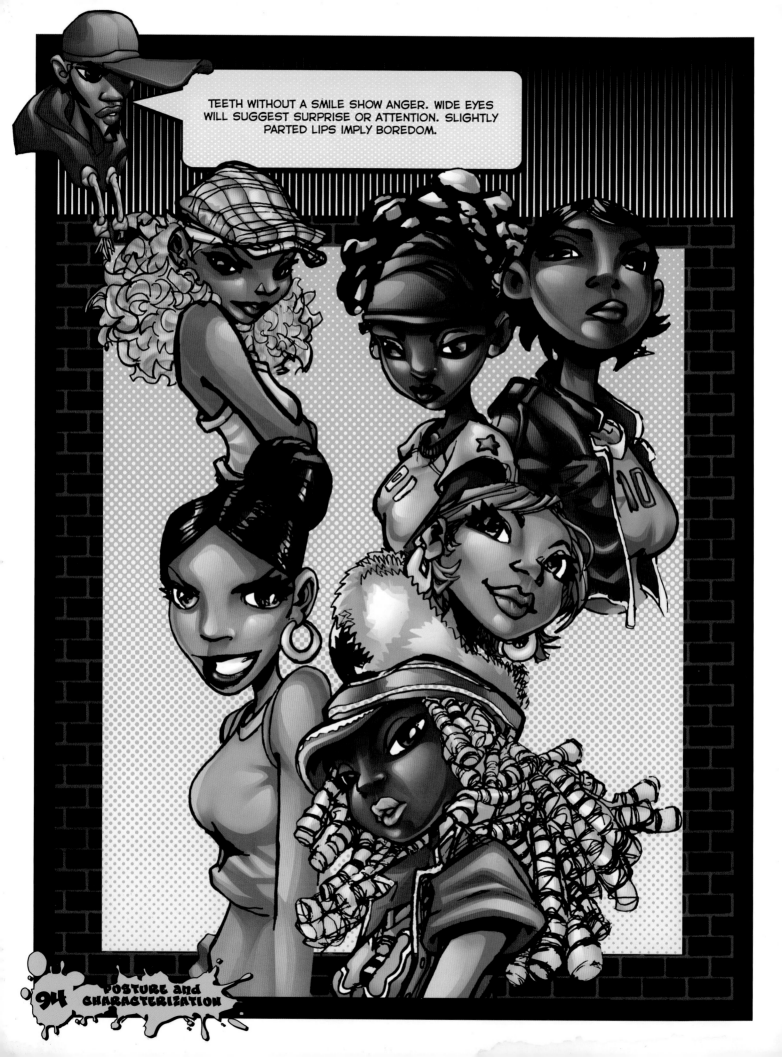

TEETH WITHOUT A SMILE SHOW ANGER. WIDE EYES WILL SUGGEST SURPRISE OR ATTENTION. SLIGHTLY PARTED LIPS IMPLY BOREDOM.

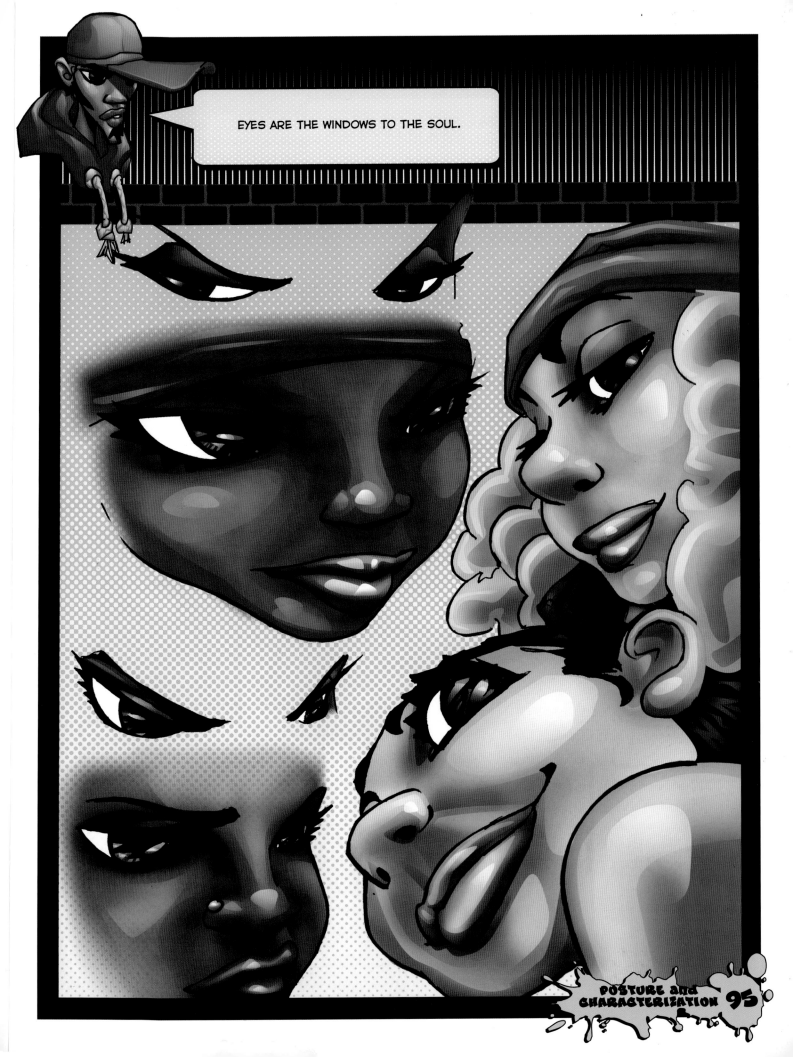

EYES ARE THE WINDOWS TO THE SOUL.

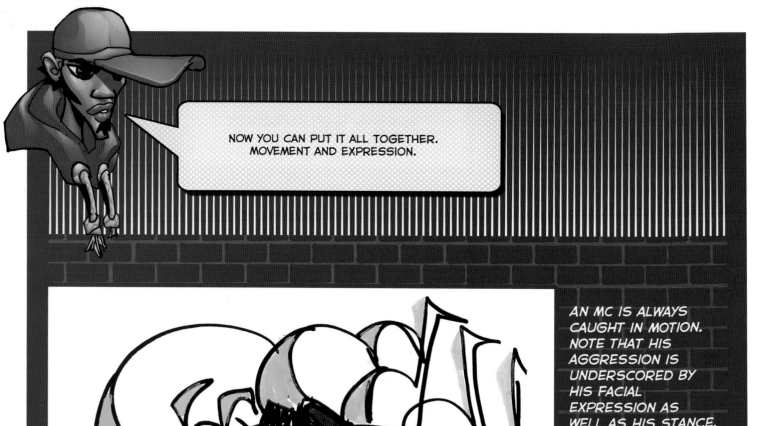

NOW YOU CAN PUT IT ALL TOGETHER. MOVEMENT AND EXPRESSION.

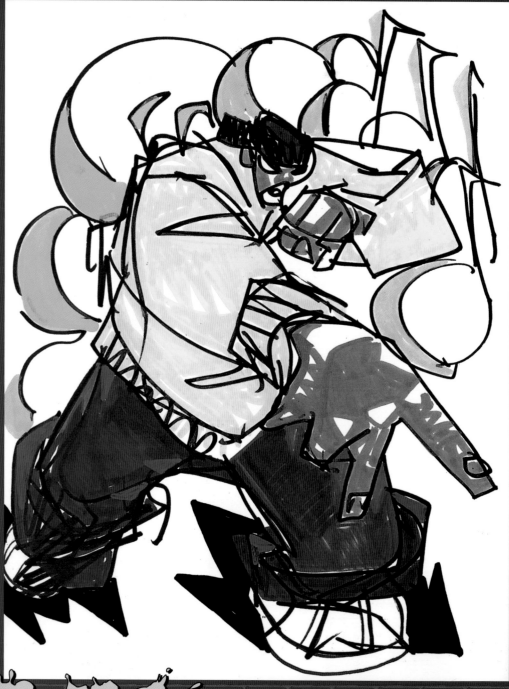

AN MC IS ALWAYS CAUGHT IN MOTION. NOTE THAT HIS AGGRESSION IS UNDERSCORED BY HIS FACIAL EXPRESSION AS WELL AS HIS STANCE.

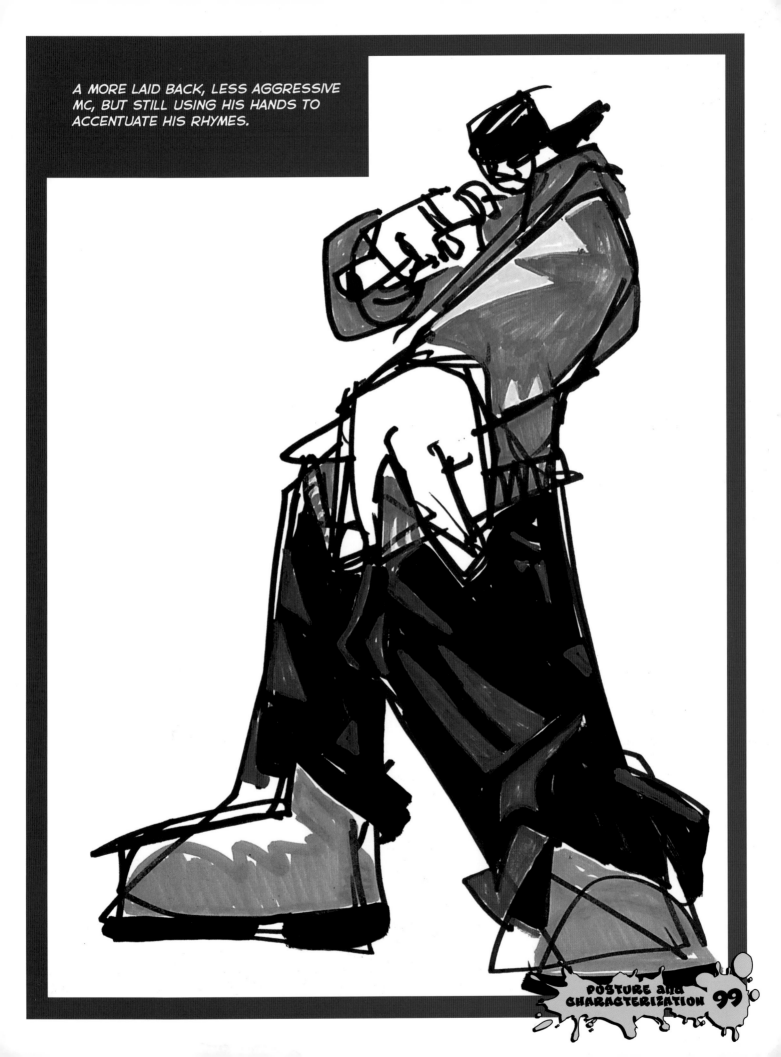

A MORE LAID BACK, LESS AGGRESSIVE MC, BUT STILL USING HIS HANDS TO ACCENTUATE HIS RHYMES.

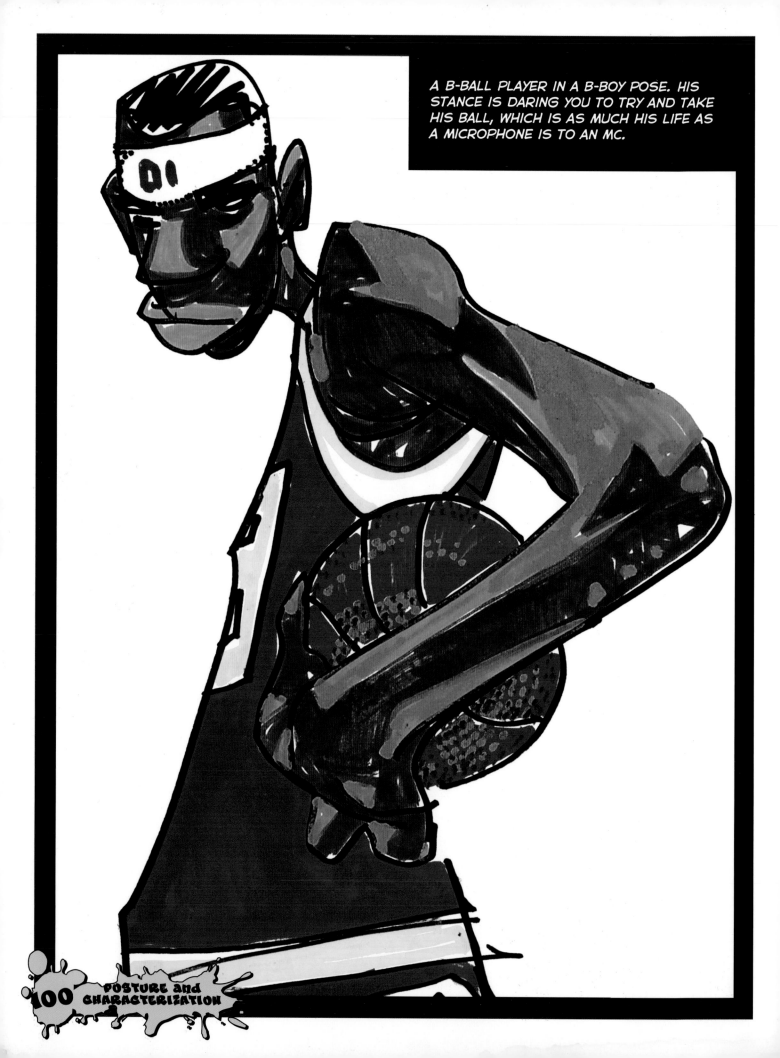

A B-BALL PLAYER IN A B-BOY POSE. HIS STANCE IS DARING YOU TO TRY AND TAKE HIS BALL, WHICH IS AS MUCH HIS LIFE AS A MICROPHONE IS TO AN MC.

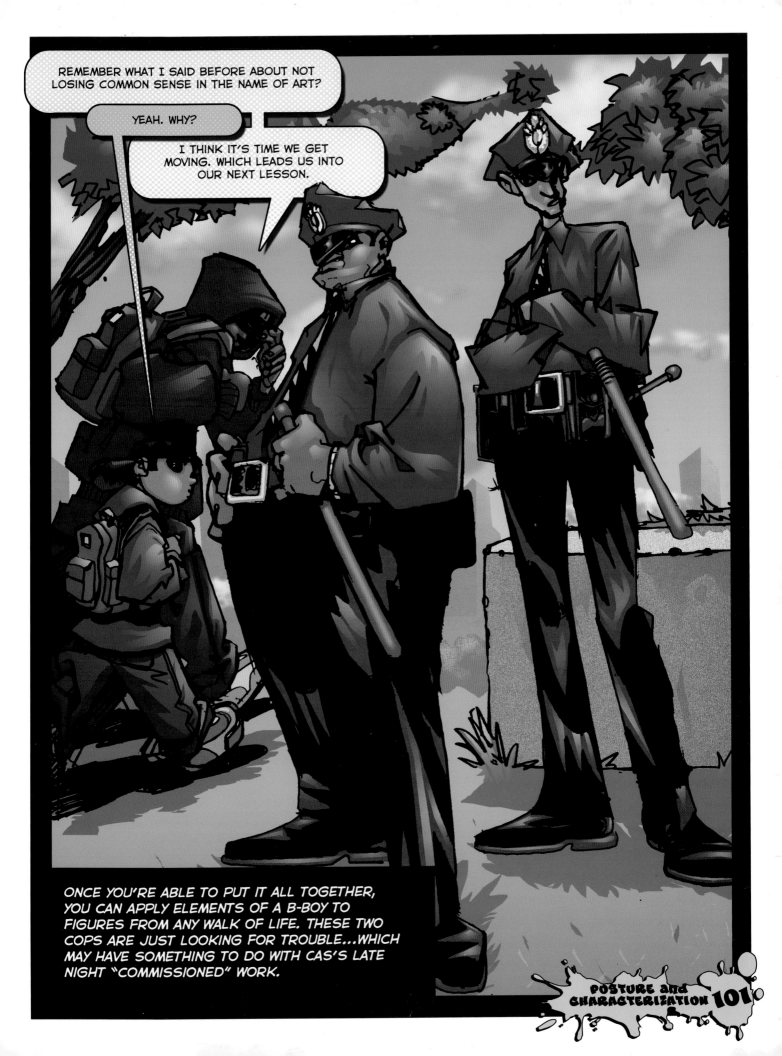

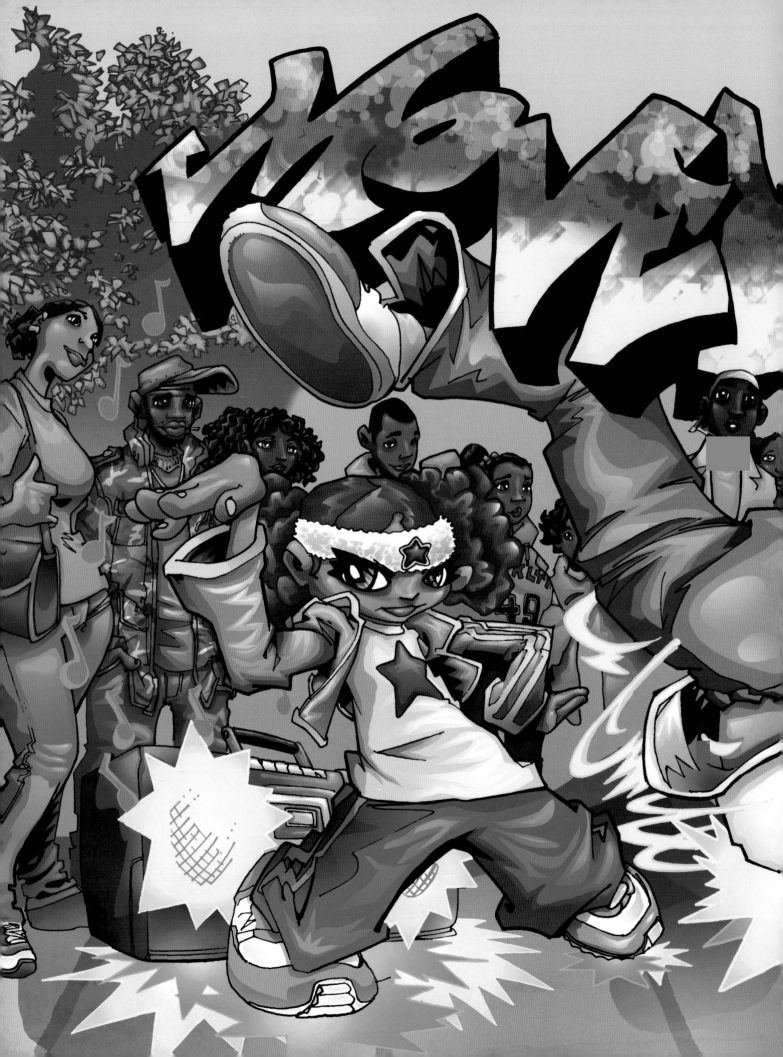

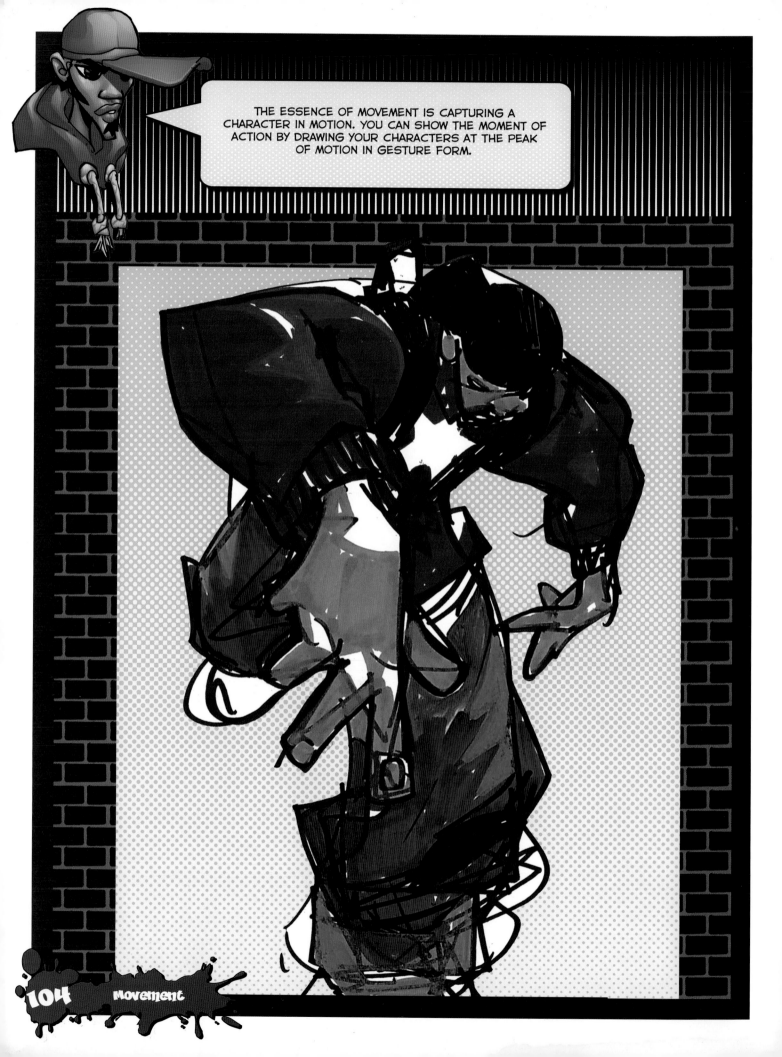

THE ESSENCE OF MOVEMENT IS CAPTURING A CHARACTER IN MOTION. YOU CAN SHOW THE MOMENT OF ACTION BY DRAWING YOUR CHARACTERS AT THE PEAK OF MOTION IN GESTURE FORM.

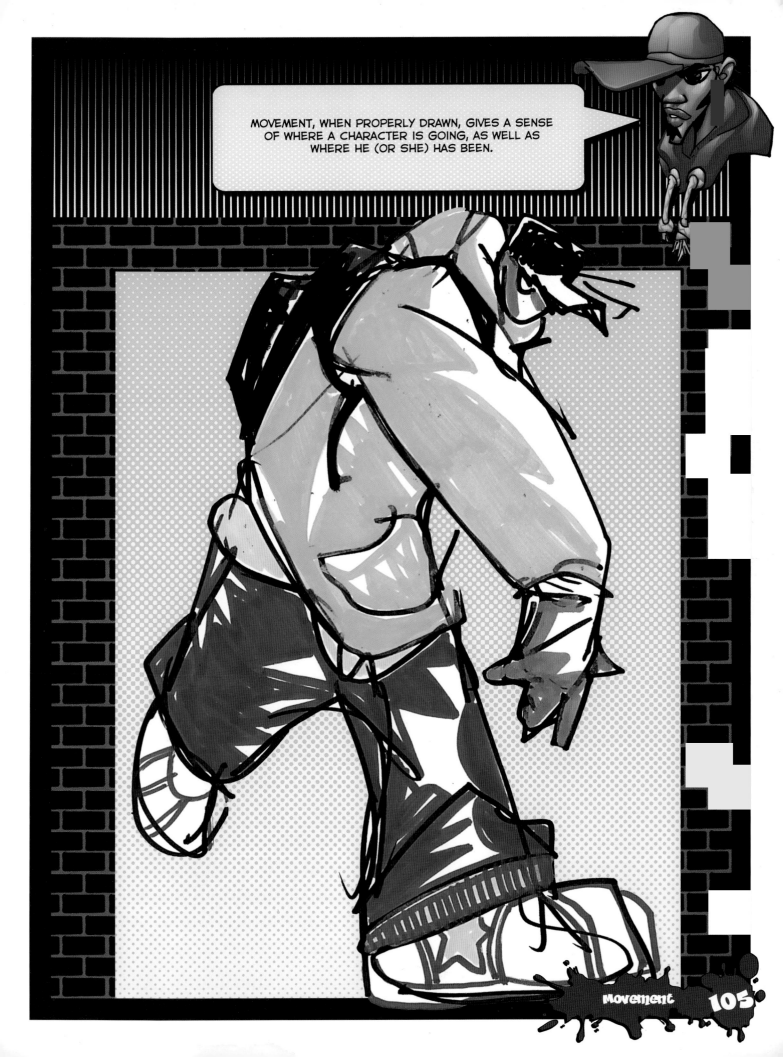

MOVEMENT, WHEN PROPERLY DRAWN, GIVES A SENSE OF WHERE A CHARACTER IS GOING, AS WELL AS WHERE HE (OR SHE) HAS BEEN.

KEEPING IT MOVING.

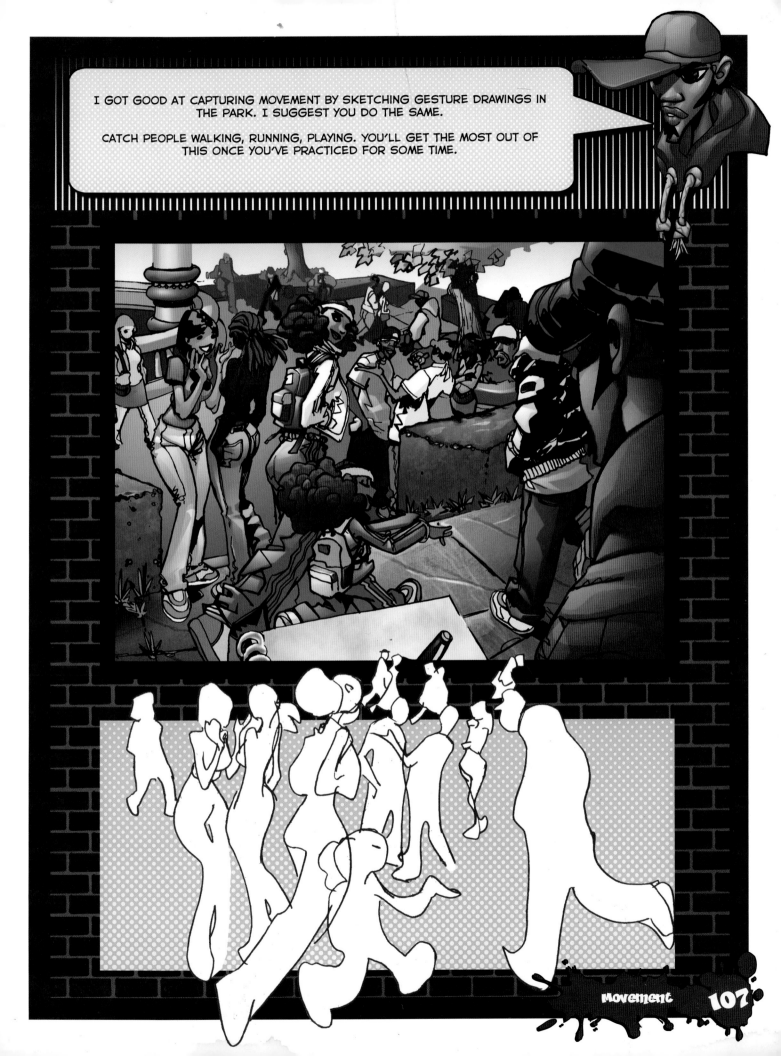

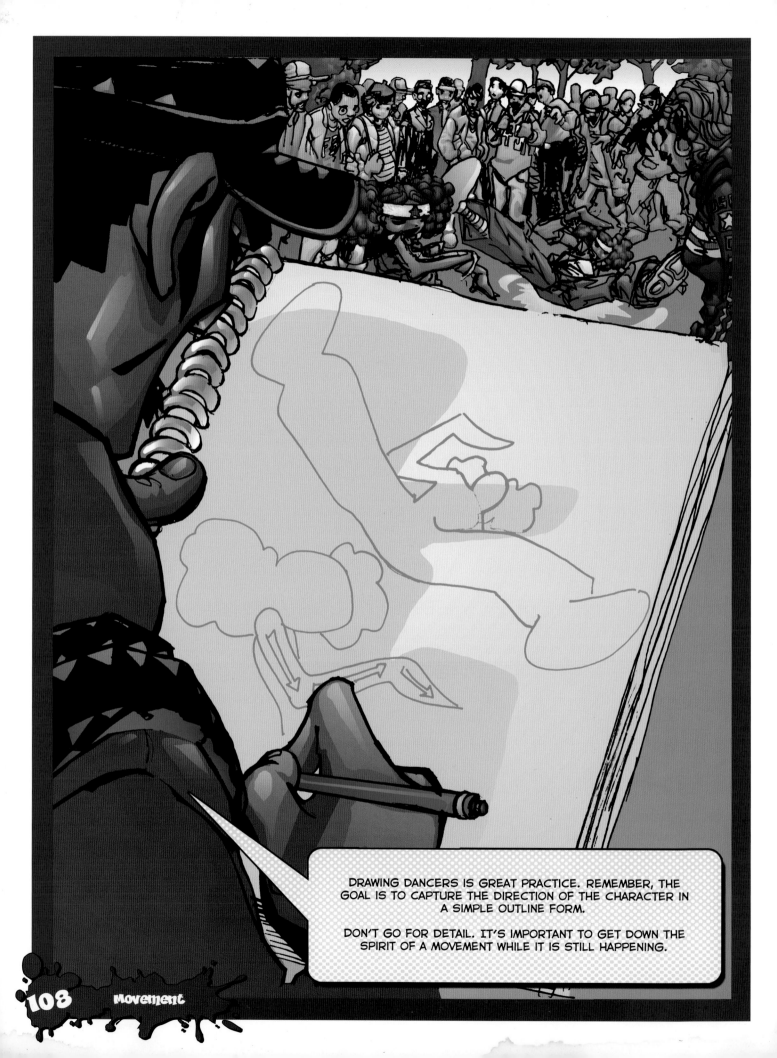

DRAWING DANCERS IS GREAT PRACTICE. REMEMBER, THE GOAL IS TO CAPTURE THE DIRECTION OF THE CHARACTER IN A SIMPLE OUTLINE FORM.

DON'T GO FOR DETAIL. IT'S IMPORTANT TO GET DOWN THE SPIRIT OF A MOVEMENT WHILE IT IS STILL HAPPENING.

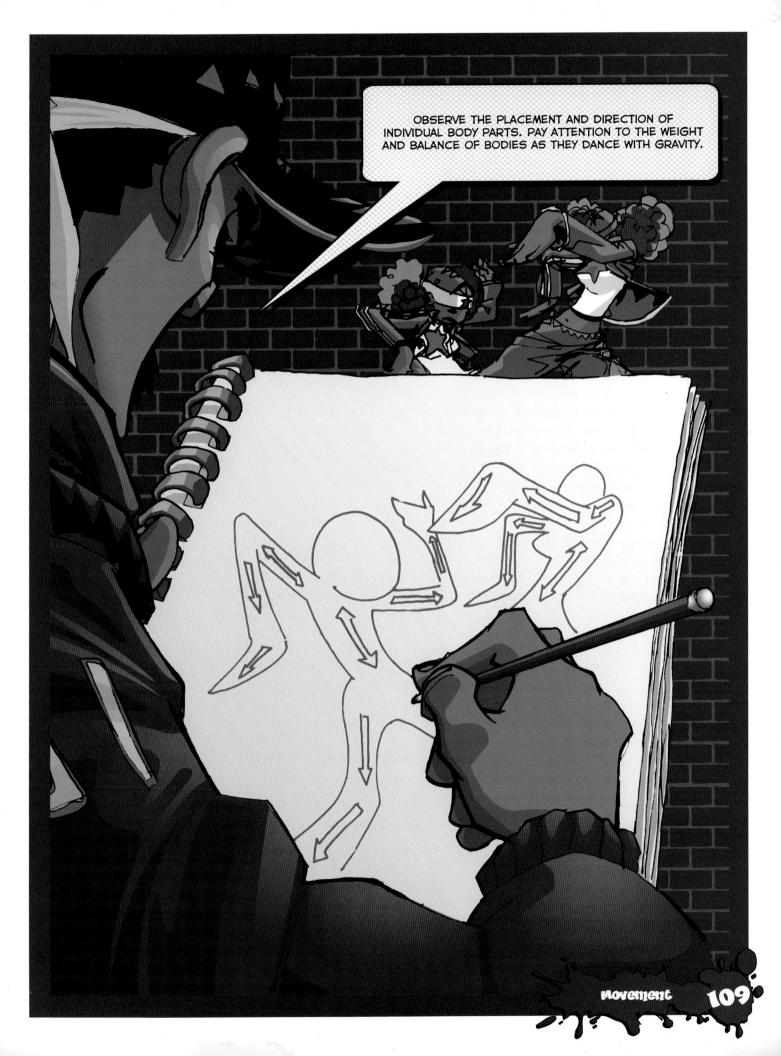

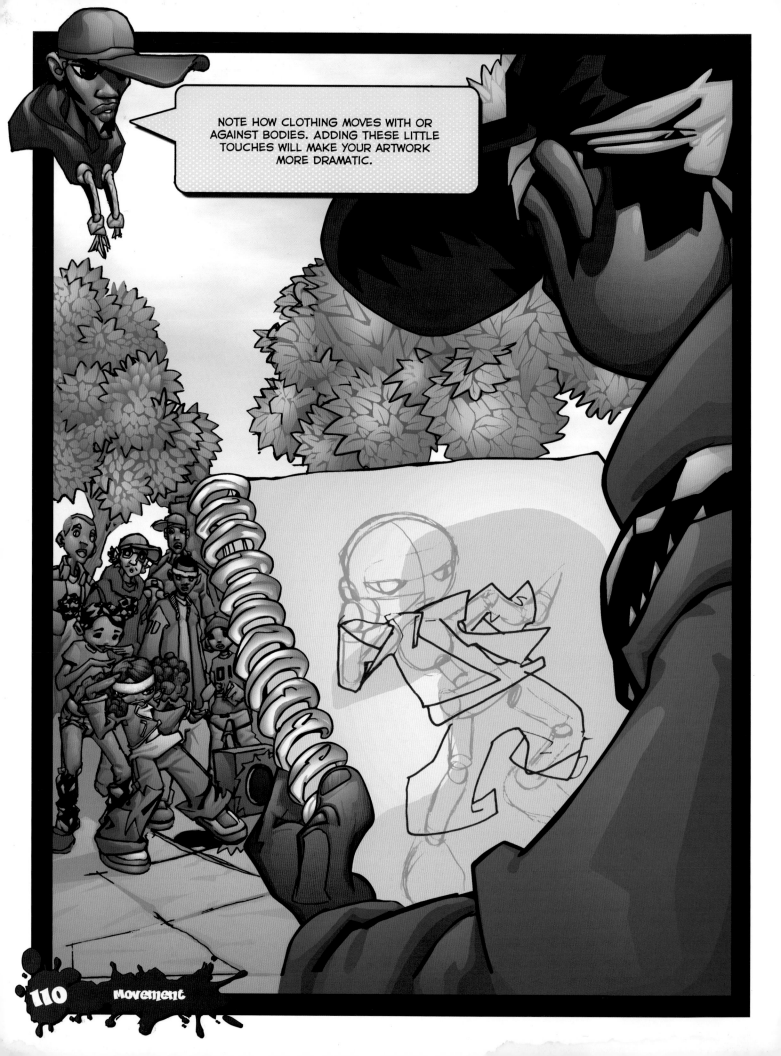

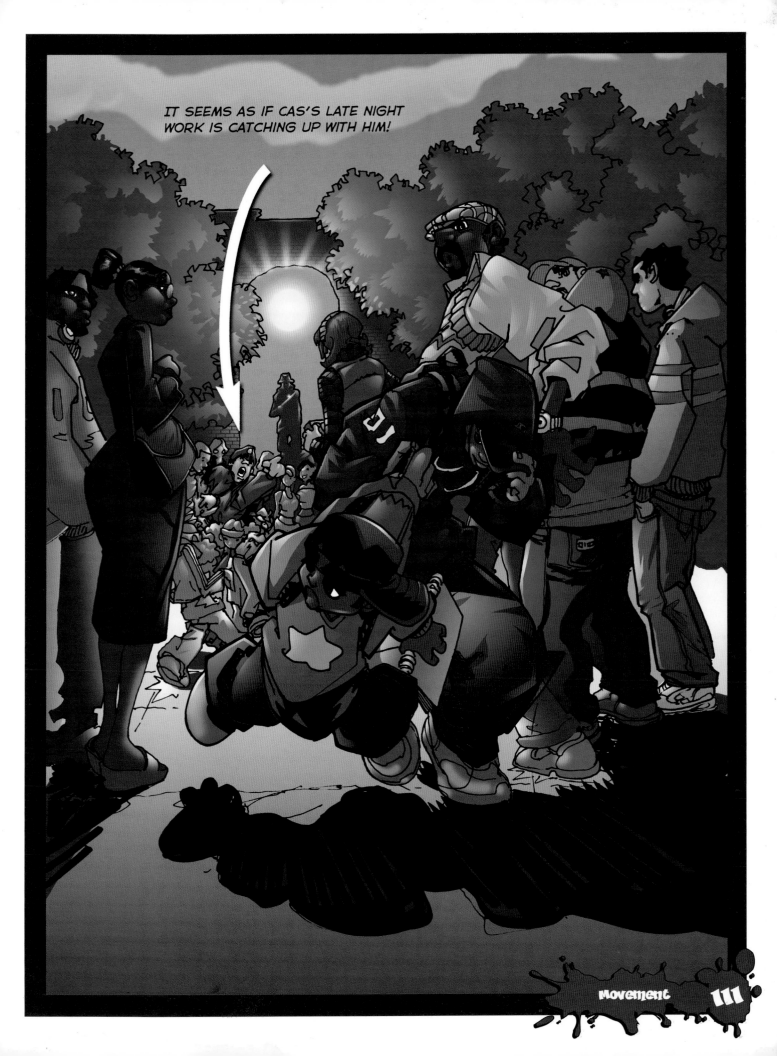

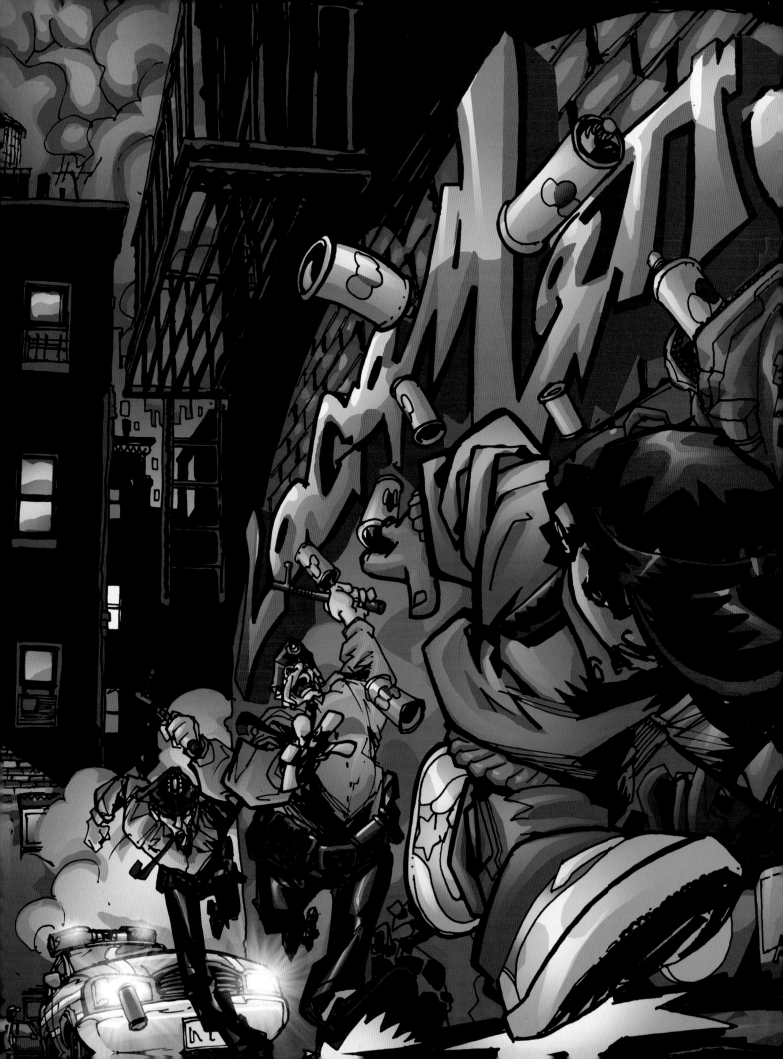

NOW LET'S STUDY MOVEMENT OF THE ENTIRE PICTURE, WHICH IS KNOWN AS COMPOSITION. FOR OUR PURPOSES, WE'LL BE REFERRING TO A SPECIFIC PART OF COMPOSITION KNOWN AS LOCOMOTION, THE ART OF CREATING MOTION IN PICTURE COMPOSITION. THE TERM LOCOMOTION IS A NOD TO ONE OF HIP-HOP ART'S EARLIEST CANVASES: SUBWAY CARS. LIKE TRAIN CARS, A COMPOSITION CAN BE SEEN AS SEPARATE OBJECTS THAT ARE MOVING IN ONE DIRECTION.

YOU CAN GET EXPOSURE TO THE PROPER USE OF LOCOMOTION BY STUDYING SOME QUALITY GRAFFITI. (UNLIKE THE EARLY VOYEURS, THIS CAN BE DONE WITHOUT WAITING FOR ELEVATED TRAINS TO PASS THROUGH THE 'HOOD; THERE ARE MANY GOOD BOOKS, MAGAZINES, AND WEB SITES THAT WILL ALLOW YOU TO PORE OVER CLASSIC ART WITHOUT TAKING A TRIP TO THE HEART OF THE CONCRETE JUNGLE.) YOU'LL NOTICE THAT THERE'S A CERTAIN HARMONY THROUGHOUT THE PLACEMENT OF THE CHARACTERS AND BACKGROUND.

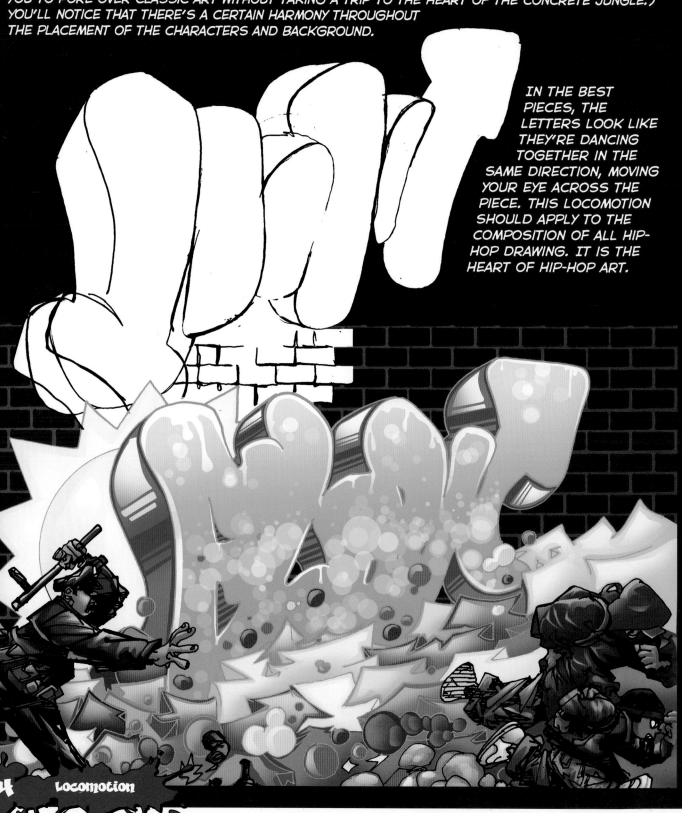

IN THE BEST PIECES, THE LETTERS LOOK LIKE THEY'RE DANCING TOGETHER IN THE SAME DIRECTION, MOVING YOUR EYE ACROSS THE PIECE. THIS LOCOMOTION SHOULD APPLY TO THE COMPOSITION OF ALL HIP-HOP DRAWING. IT IS THE HEART OF HIP-HOP ART.

MANY WRITTEN GRAFFITI PIECES HAVE A LEFT TO RIGHT MOVEMENT, WITH MOST LETTERS OVERLAPPING THE ONES THAT COME NEXT. EACH LETTER BLENDS INTO THE NEXT, PUSHING YOUR EYE ACROSS THE WORD. SOMETIMES THIS PROCESS IS REVERSED, WHICH GIVES THE WRITTEN WORD THE APPEARANCE OF MOVING BACKWARDS OR FALLING ON ITSELF.

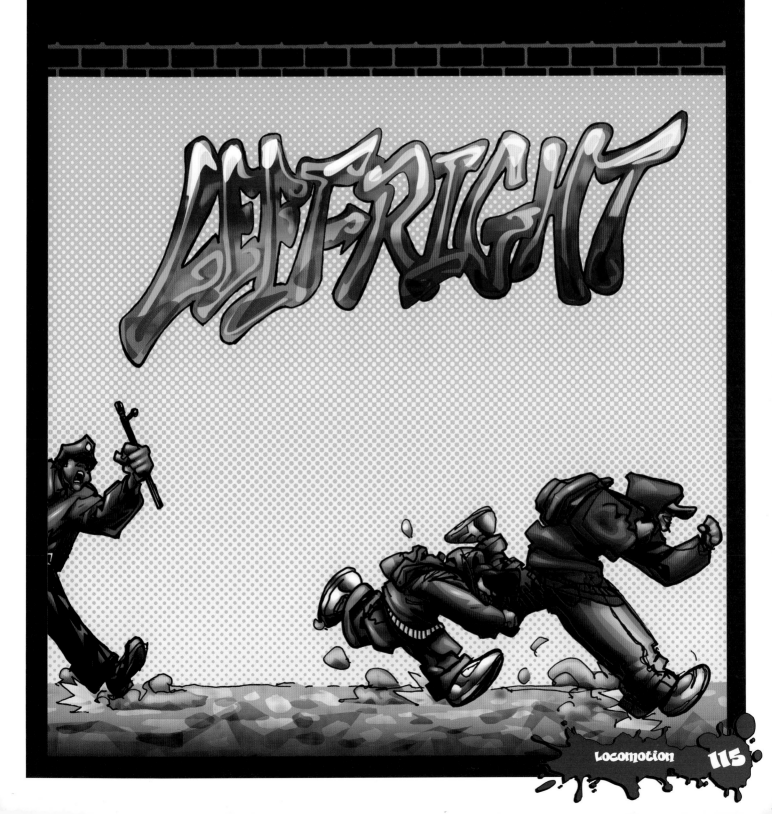

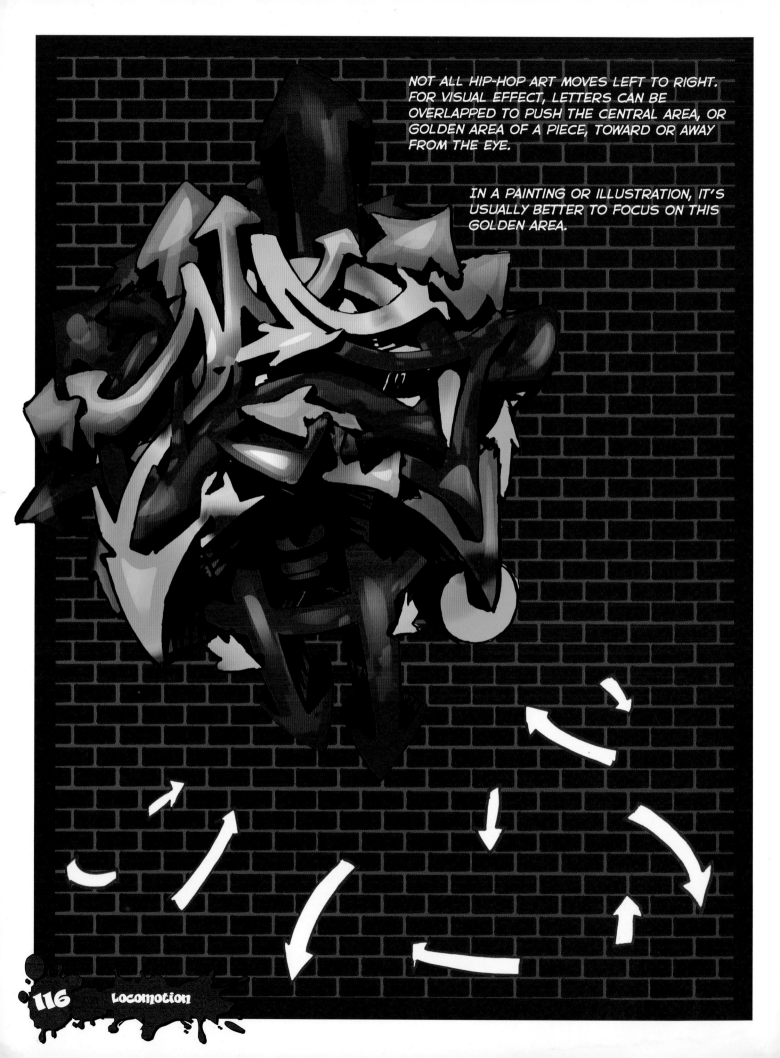

NOT ALL HIP-HOP ART MOVES LEFT TO RIGHT. FOR VISUAL EFFECT, LETTERS CAN BE OVERLAPPED TO PUSH THE CENTRAL AREA, OR GOLDEN AREA OF A PIECE, TOWARD OR AWAY FROM THE EYE.

IN A PAINTING OR ILLUSTRATION, IT'S USUALLY BETTER TO FOCUS ON THIS GOLDEN AREA.

EXPERIMENT WITH DIFFERENT MOVEMENTS, LEADING THE EYE AROUND IN DIFFERENT DIRECTIONS TO CREATE LOCOMOTION WITHIN YOUR COMPOSITION.

YOU'RE THE CONDUCTOR ON A TRAIN, DRIVING THE PICTURE. PLACE THE VIEWER OF YOUR ART IN THE PASSENGER SEAT. GIVE YOUR AUDIENCE A PLEASING RIDE TO THE POINT OF YOUR PICTURE, THE FOCUS AREA.

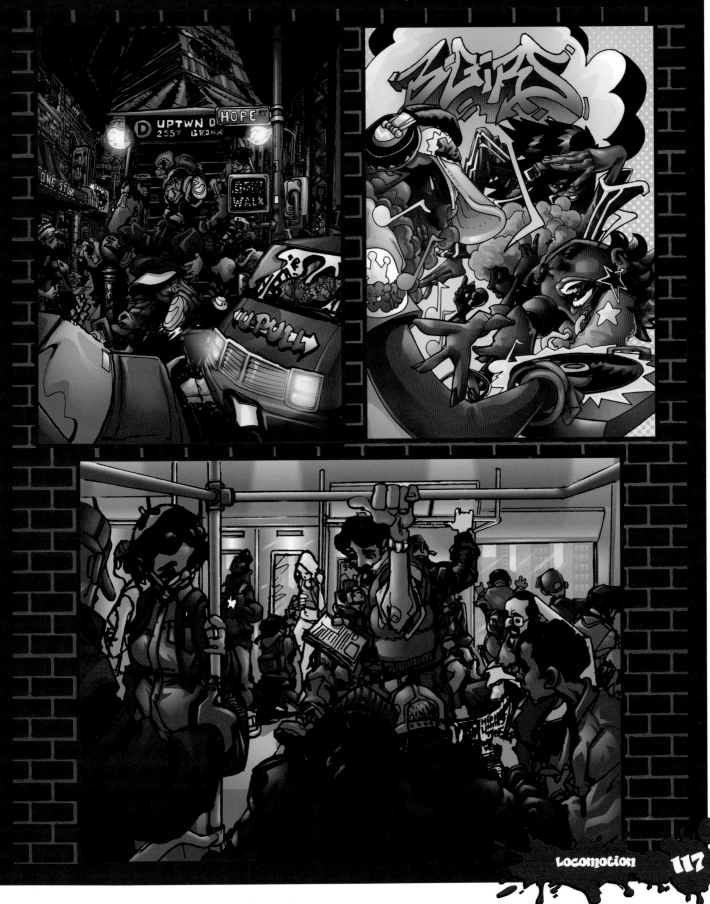

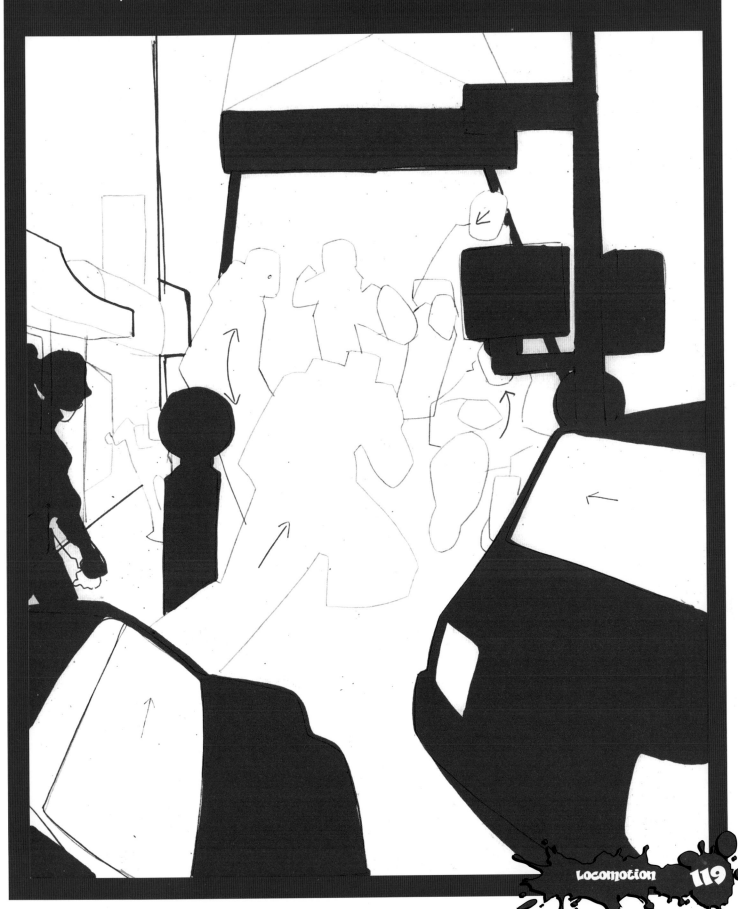

IN THIS IMAGE, CAS AND SHAY MAY SEEM LESS IMPORTANT THAN THE OTHER RIDERS, BUT WE'RE STILL ABLE TO FOCUS ON THEM THROUGH THE USE OF NEGATIVE SPACE AND LOCOMOTION.

THE LEANINGS OF THE OTHER PASSENGERS, EVEN THEIR LIMBS, LEAVE NO DOUBT AS TO WHOM THE STARS OF THIS SCENE ARE.

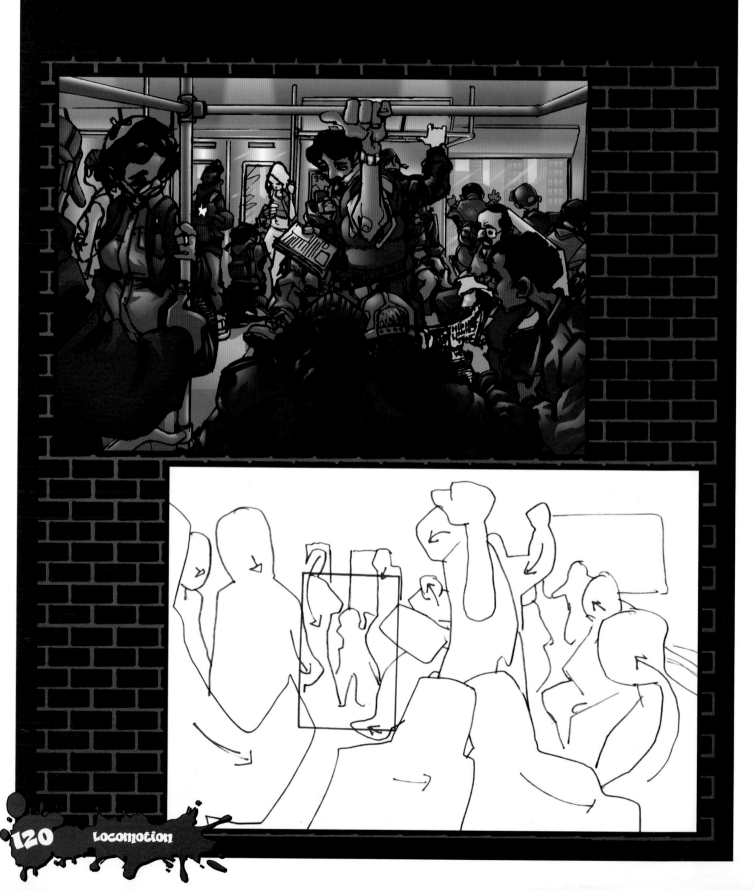

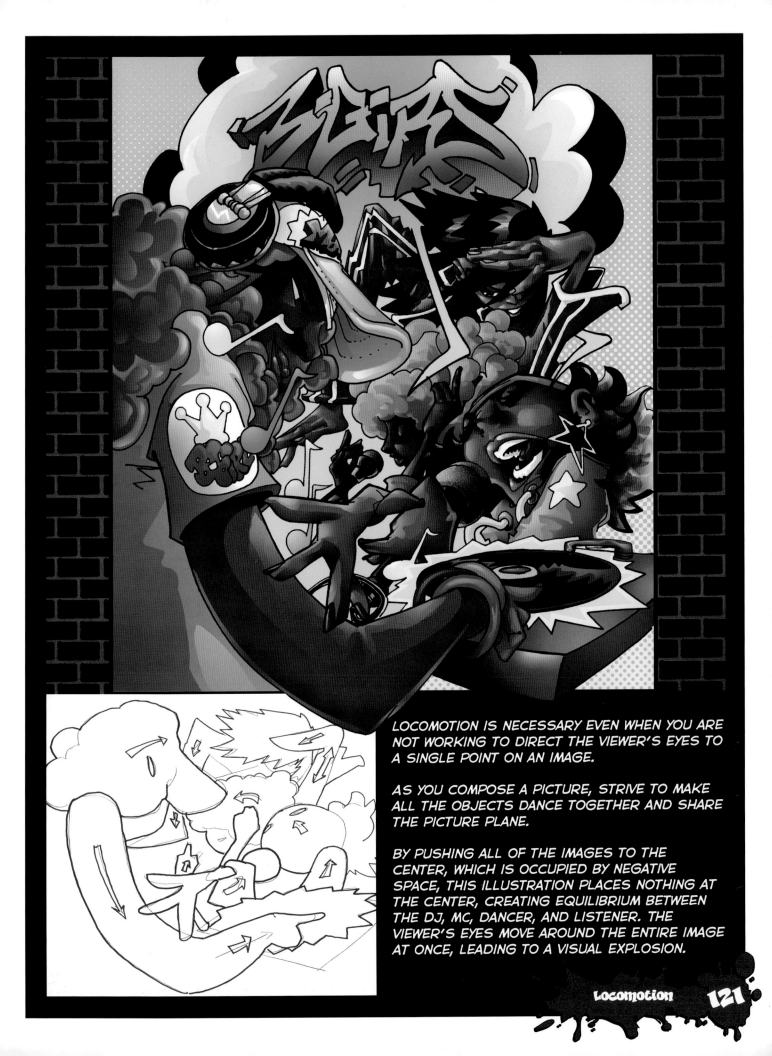

LOCOMOTION IS NECESSARY EVEN WHEN YOU ARE NOT WORKING TO DIRECT THE VIEWER'S EYES TO A SINGLE POINT ON AN IMAGE.

AS YOU COMPOSE A PICTURE, STRIVE TO MAKE ALL THE OBJECTS DANCE TOGETHER AND SHARE THE PICTURE PLANE.

BY PUSHING ALL OF THE IMAGES TO THE CENTER, WHICH IS OCCUPIED BY NEGATIVE SPACE, THIS ILLUSTRATION PLACES NOTHING AT THE CENTER, CREATING EQUILIBRIUM BETWEEN THE DJ, MC, DANCER, AND LISTENER. THE VIEWER'S EYES MOVE AROUND THE ENTIRE IMAGE AT ONCE, LEADING TO A VISUAL EXPLOSION.

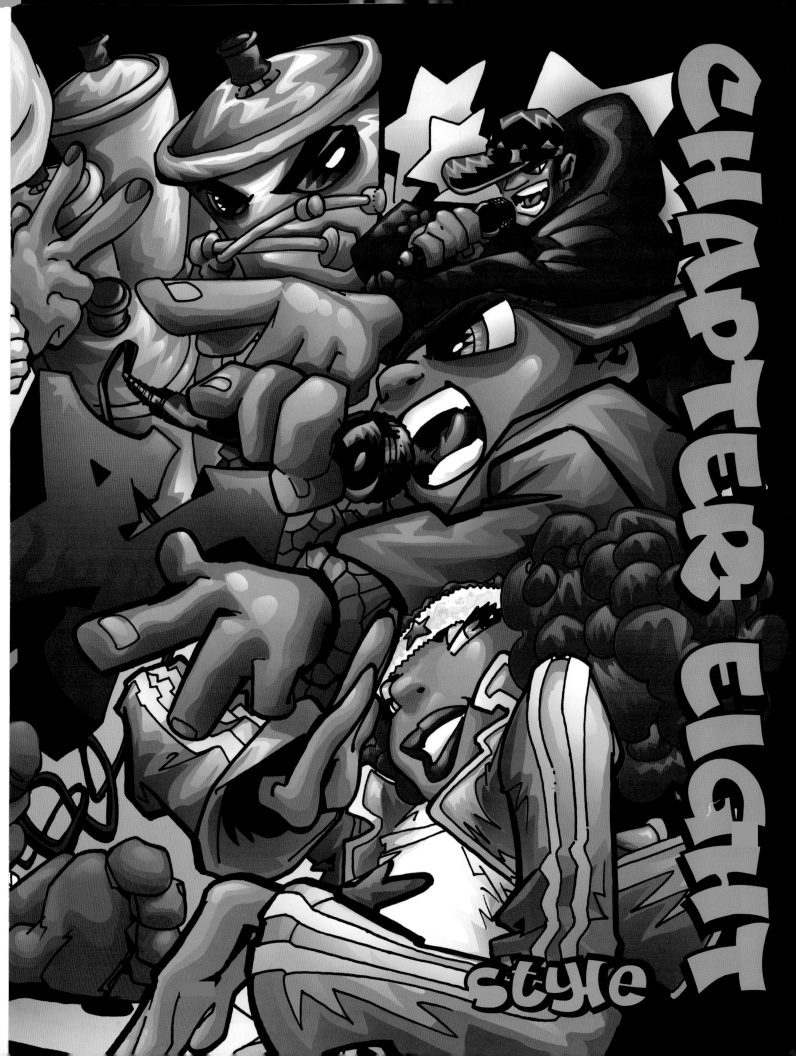

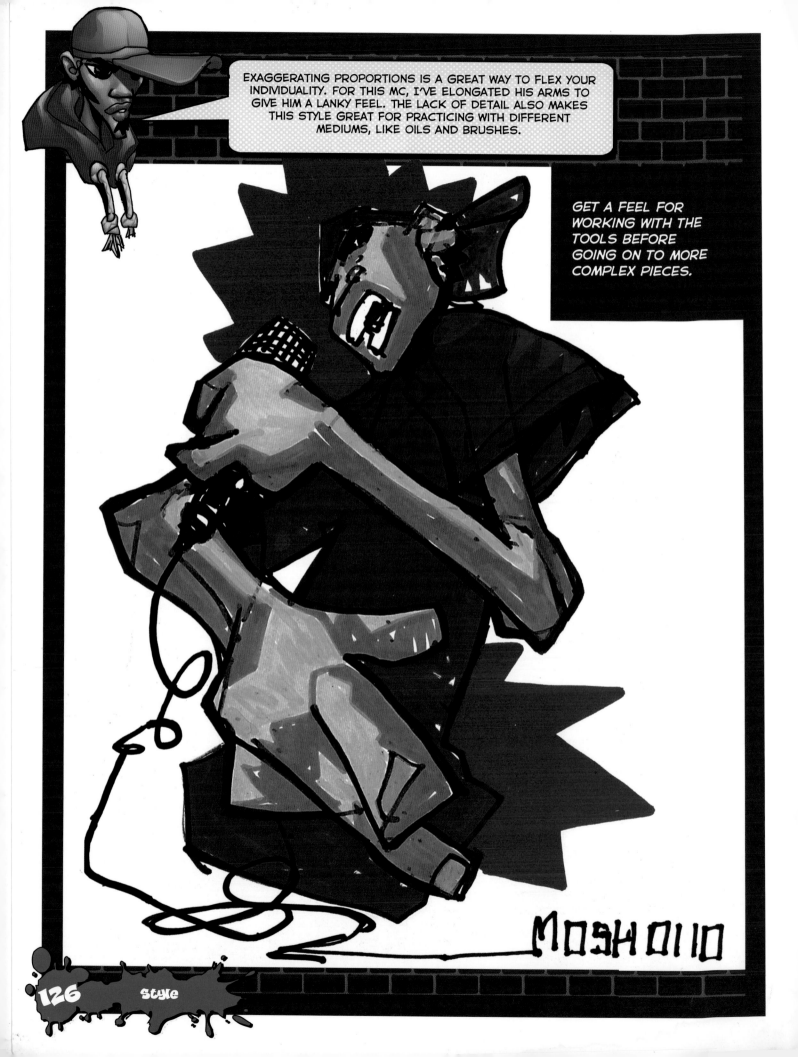

EXAGGERATING PROPORTIONS IS A GREAT WAY TO FLEX YOUR INDIVIDUALITY. FOR THIS MC, I'VE ELONGATED HIS ARMS TO GIVE HIM A LANKY FEEL. THE LACK OF DETAIL ALSO MAKES THIS STYLE GREAT FOR PRACTICING WITH DIFFERENT MEDIUMS, LIKE OILS AND BRUSHES.

GET A FEEL FOR WORKING WITH THE TOOLS BEFORE GOING ON TO MORE COMPLEX PIECES.

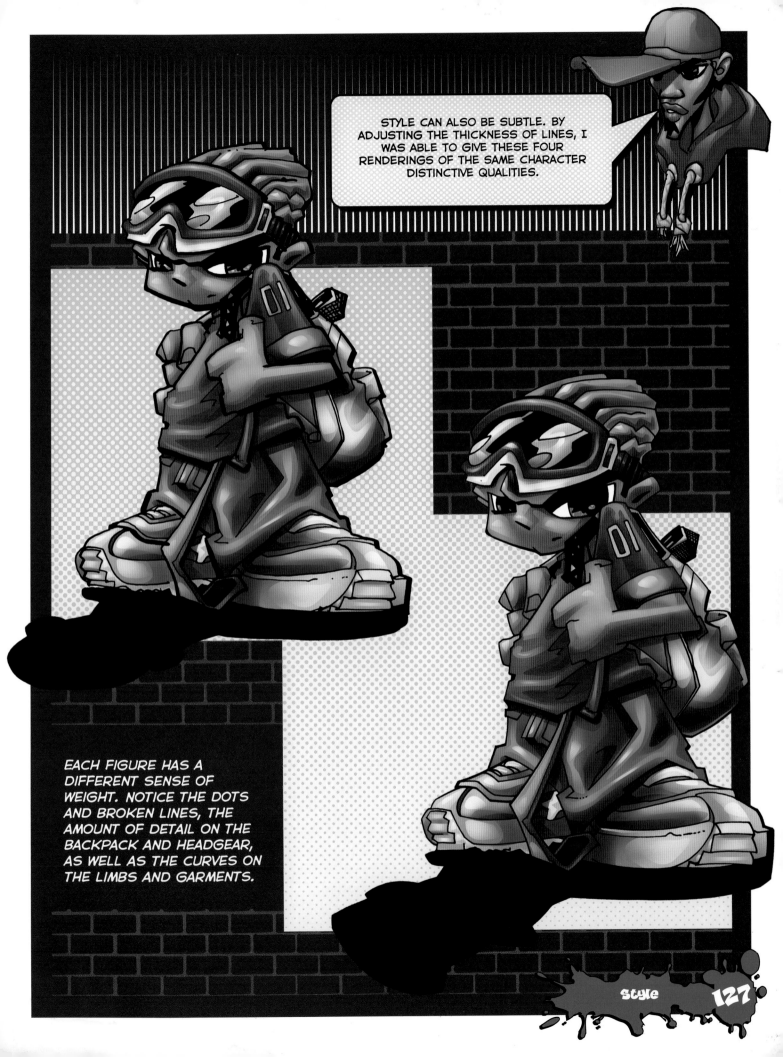

STYLE CAN ALSO BE SUBTLE. BY ADJUSTING THE THICKNESS OF LINES, I WAS ABLE TO GIVE THESE FOUR RENDERINGS OF THE SAME CHARACTER DISTINCTIVE QUALITIES.

EACH FIGURE HAS A DIFFERENT SENSE OF WEIGHT. NOTICE THE DOTS AND BROKEN LINES, THE AMOUNT OF DETAIL ON THE BACKPACK AND HEADGEAR, AS WELL AS THE CURVES ON THE LIMBS AND GARMENTS.

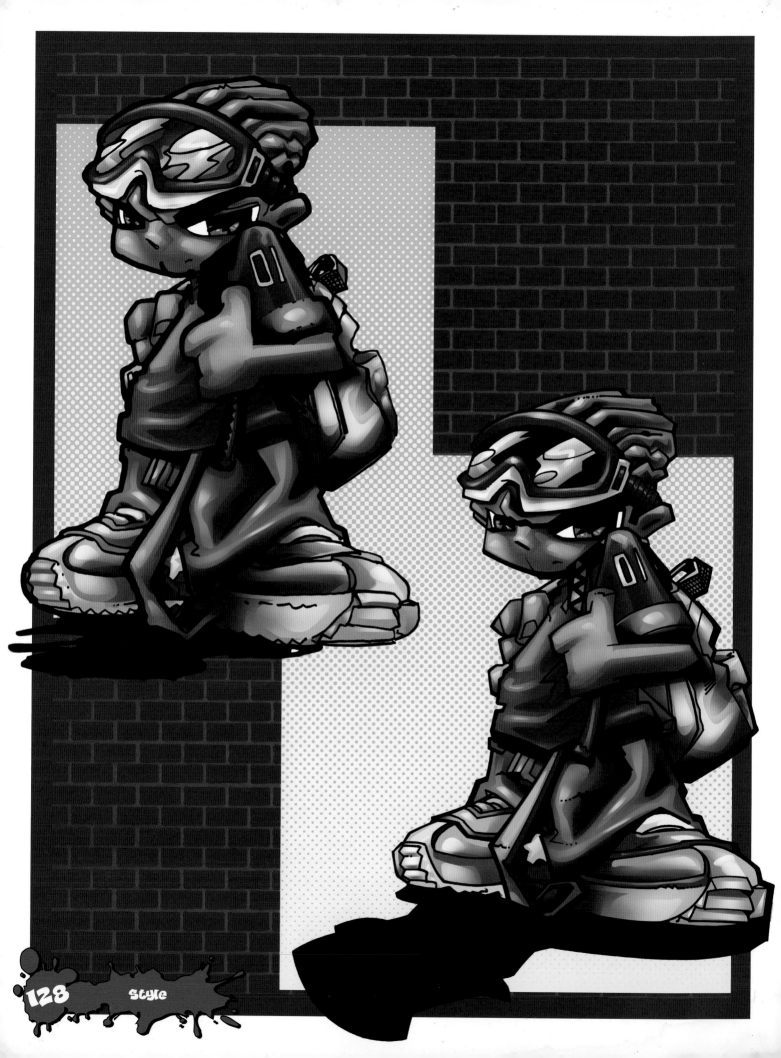

style

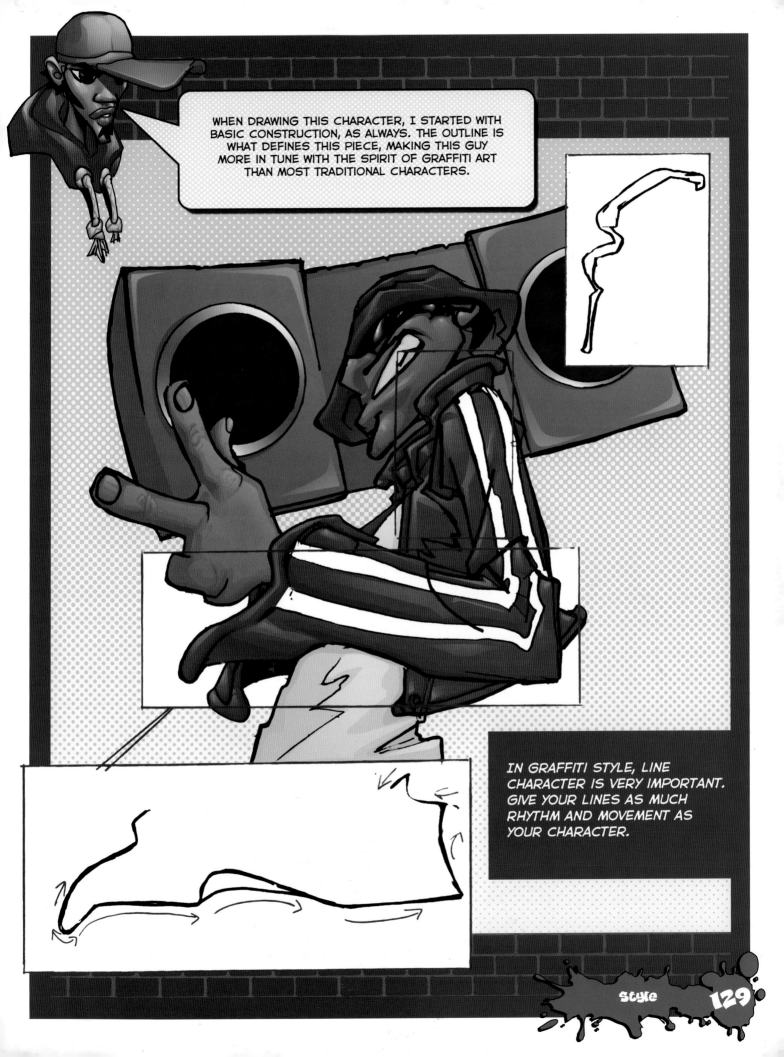

WHEN DRAWING THIS CHARACTER, I STARTED WITH BASIC CONSTRUCTION, AS ALWAYS. THE OUTLINE IS WHAT DEFINES THIS PIECE, MAKING THIS GUY MORE IN TUNE WITH THE SPIRIT OF GRAFFITI ART THAN MOST TRADITIONAL CHARACTERS.

IN GRAFFITI STYLE, LINE CHARACTER IS VERY IMPORTANT. GIVE YOUR LINES AS MUCH RHYTHM AND MOVEMENT AS YOUR CHARACTER.

FOR THIS CHARACTER I USED VERY LITTLE DETAIL, BUT ADDED EXTRA SHADING. THOUGH THE PANTS ARE BASICALLY AN OUTLINE, THE USE OF SHADING STILL IMPLIES THE DRAPERY OF THE GARMENT.

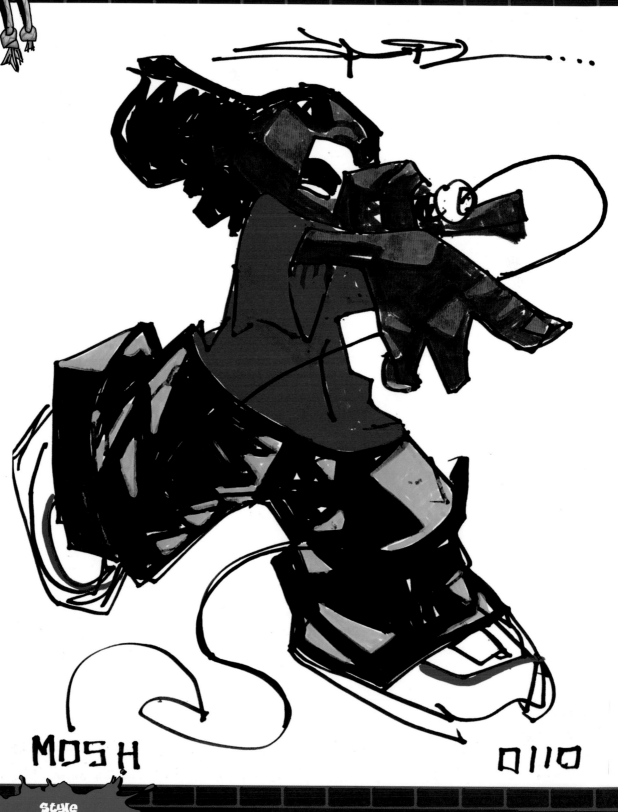

MOSH

0110

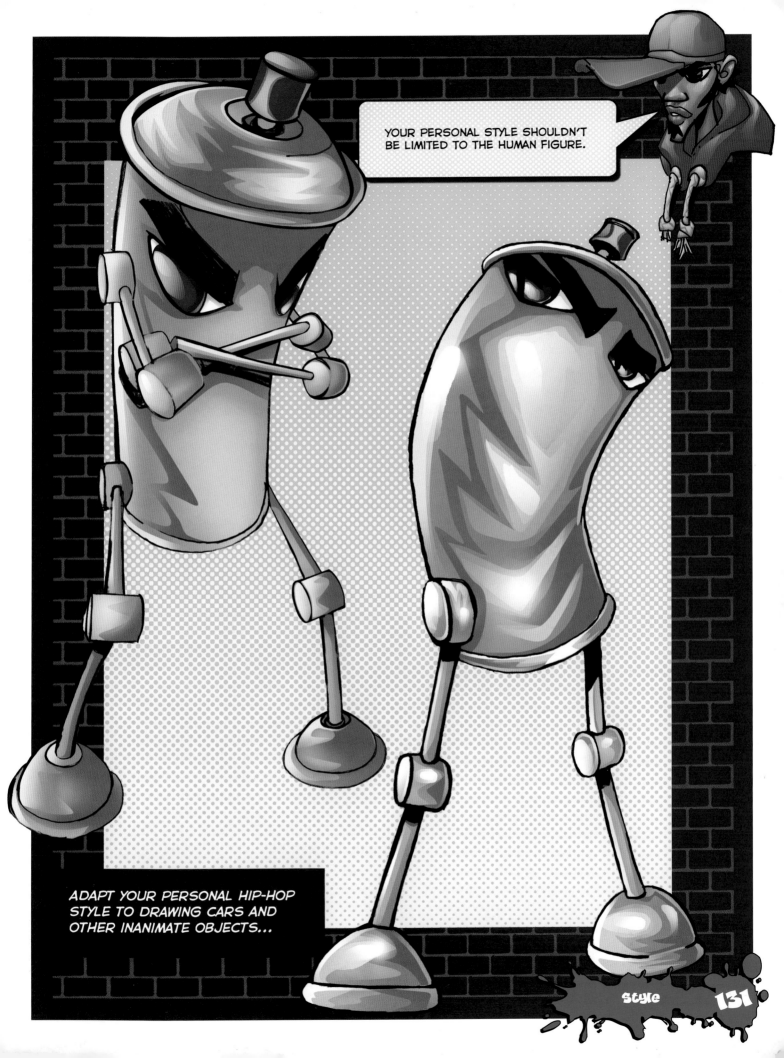

YOUR PERSONAL STYLE SHOULDN'T BE LIMITED TO THE HUMAN FIGURE.

ADAPT YOUR PERSONAL HIP-HOP STYLE TO DRAWING CARS AND OTHER INANIMATE OBJECTS...

...OR WHATEVER ELSE COMES TO MIND.

style

epilogue

WHATEVER YOU DO, ONE THING IS IMPORTANT TO REMEMBER: YOU HAVE TO LEARN THE RULES OF ART BEFORE YOU CAN BREAK THEM.

IT'S ESSENTIAL THAT YOU HAVE A FIRM GRASP OF THE BASICS (SHAPES, FORMS, AND CONSTRUCTION) BEFORE EXPERIMENTING OUTSIDE OF THE LINES, SO TO SPEAK.

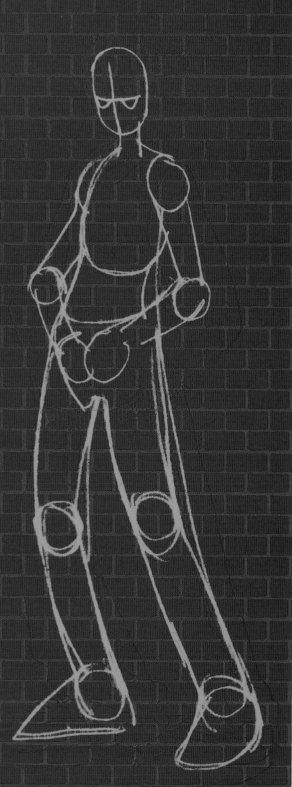

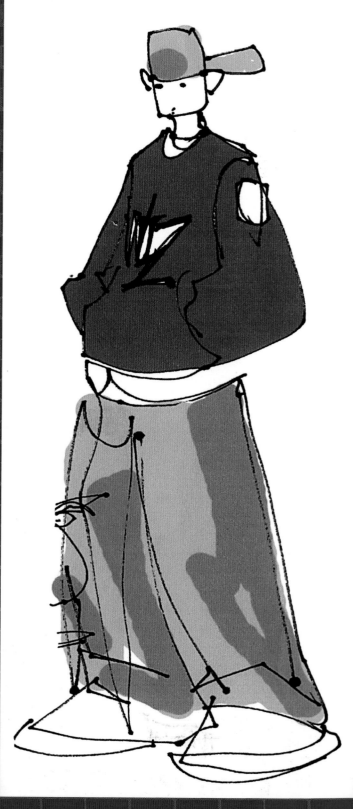

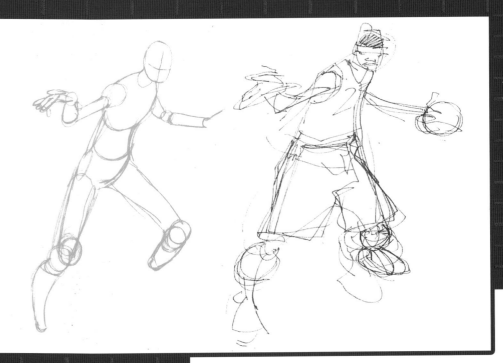

PAY SPECIAL ATTENTION TO THE ATTITUDE OR PERSONALITY BEING EXPRESSED WHEN YOU POSE YOUR CHARACTERS.

TAKING TIME TO BUILD A STRONG FOUNDATION WILL PROVIDE YOU WITH THE SKILL SET NECESSARY TO TAKE YOUR ART TO LEVELS YOU CAN ONLY NOW IMAGINE.

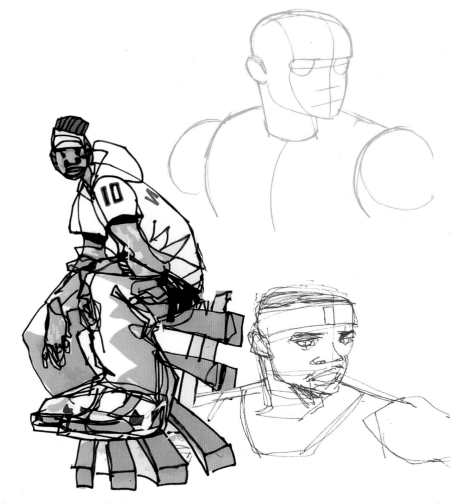

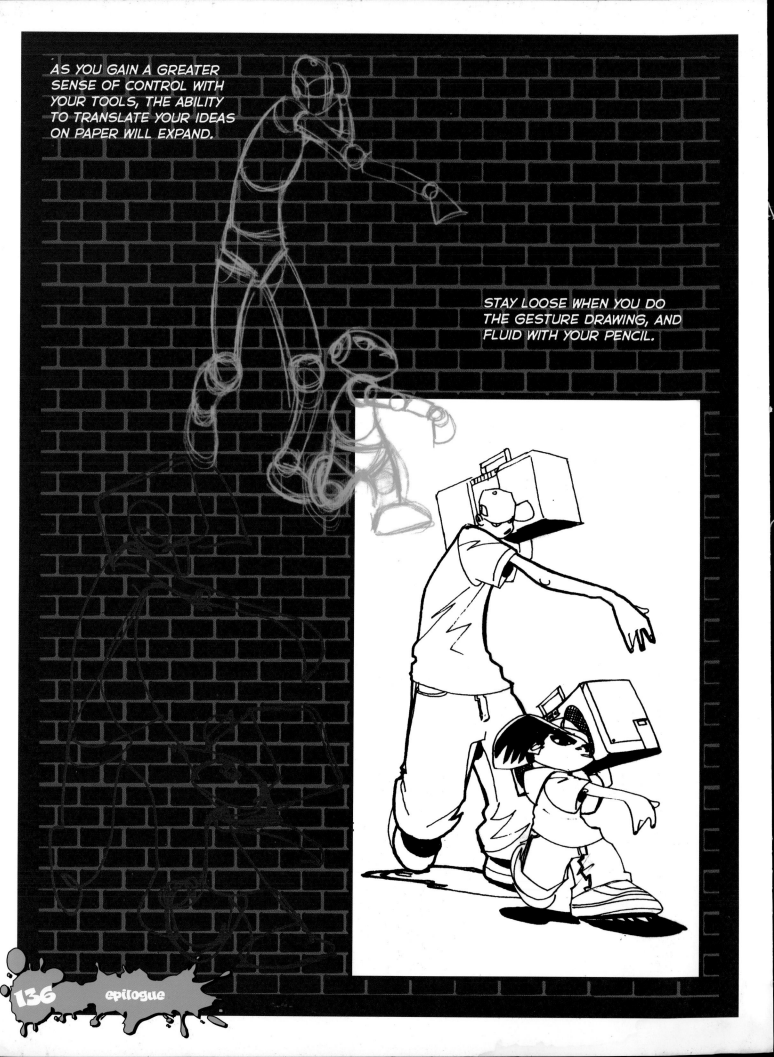

AS YOU GAIN A GREATER
SENSE OF CONTROL WITH
YOUR TOOLS, THE ABILITY
TO TRANSLATE YOUR IDEAS
ON PAPER WILL EXPAND.

STAY LOOSE WHEN YOU DO
THE GESTURE DRAWING, AND
FLUID WITH YOUR PENCIL.

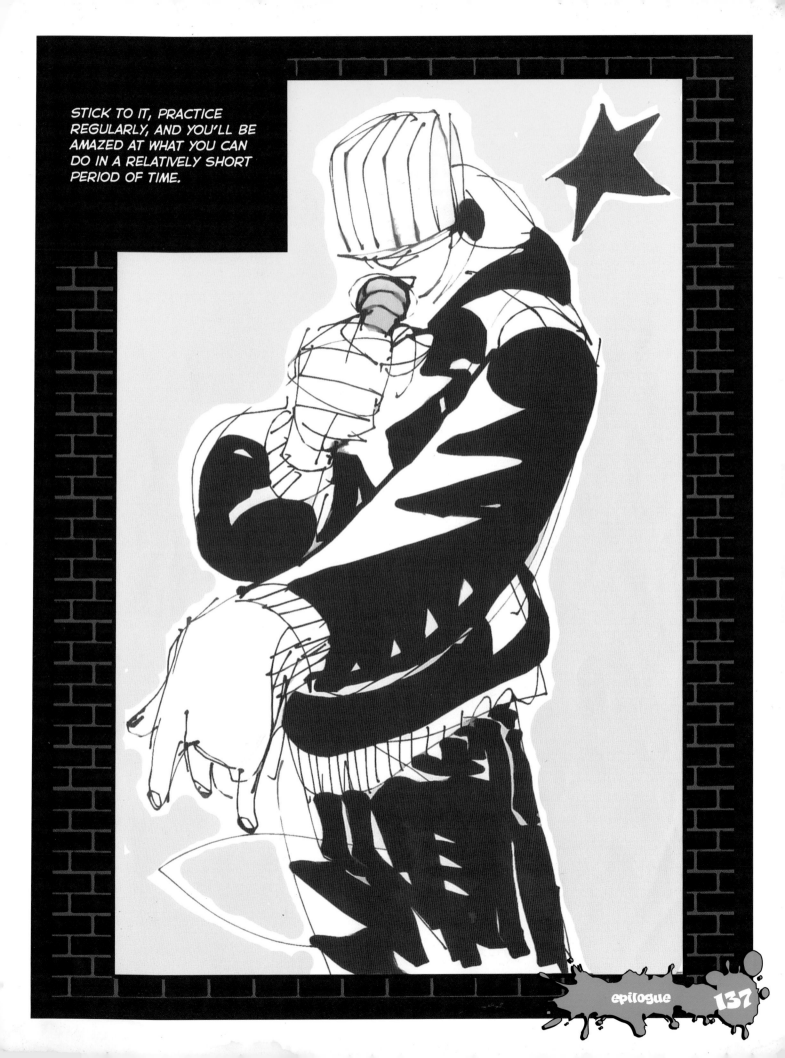

STICK TO IT, PRACTICE REGULARLY, AND YOU'LL BE AMAZED AT WHAT YOU CAN DO IN A RELATIVELY SHORT PERIOD OF TIME.

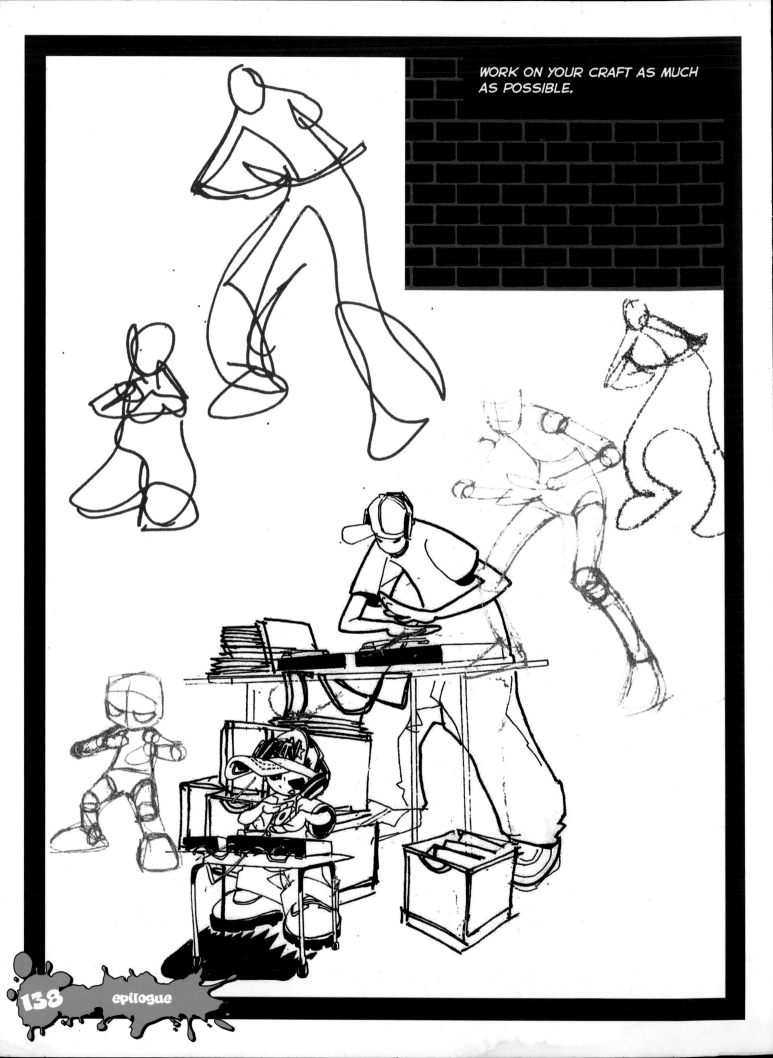

WORK ON YOUR CRAFT AS MUCH AS POSSIBLE.

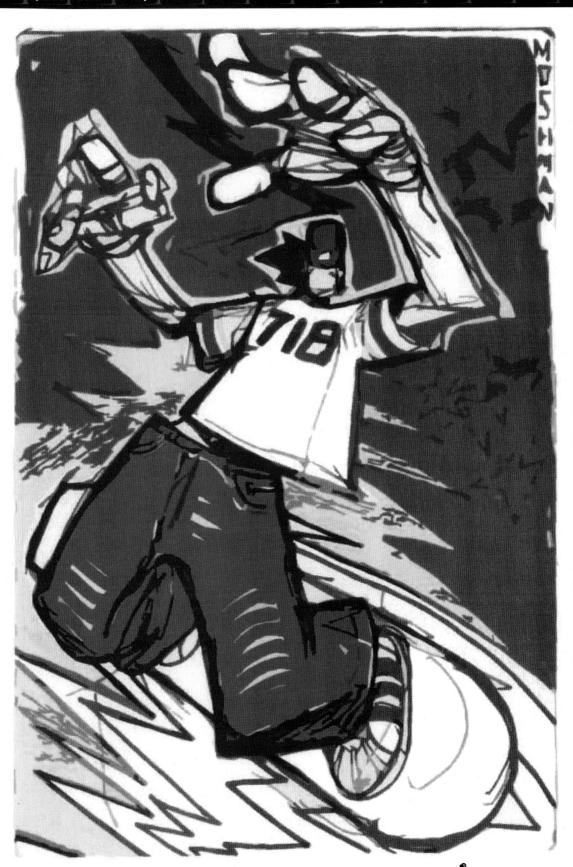

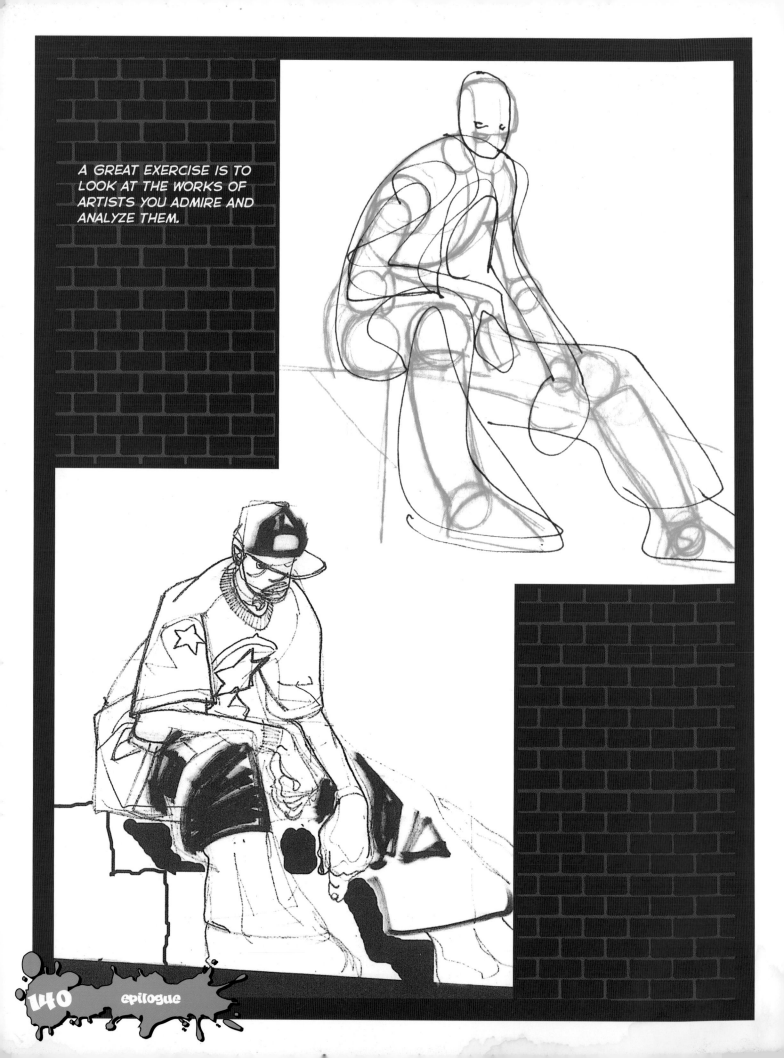

A GREAT EXERCISE IS TO LOOK AT THE WORKS OF ARTISTS YOU ADMIRE AND ANALYZE THEM.

FIND PICTURES OF GRAFFITI PIECES (READILY AVAILABLE ONLINE), COMIC BOOKS, OR OTHER EXAMPLES OF ART YOU LIKE AND SEE IF YOU CAN DECIPHER WHAT SHAPES AND FORMS THE ARTIST USED.

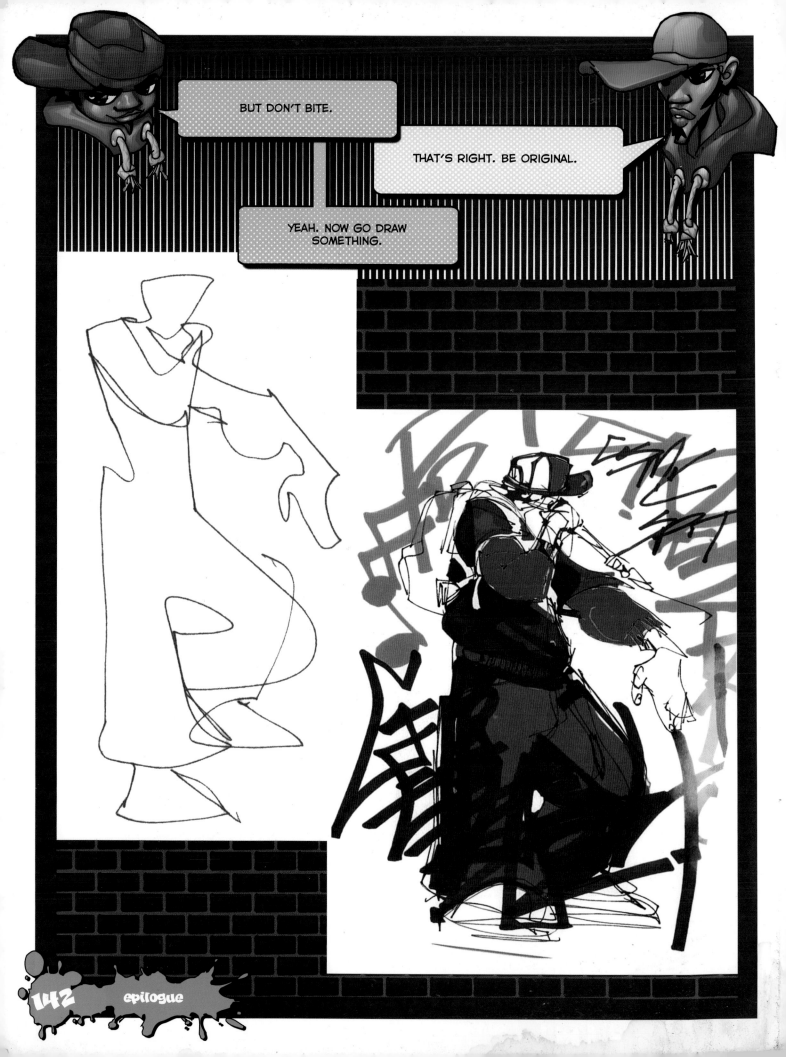

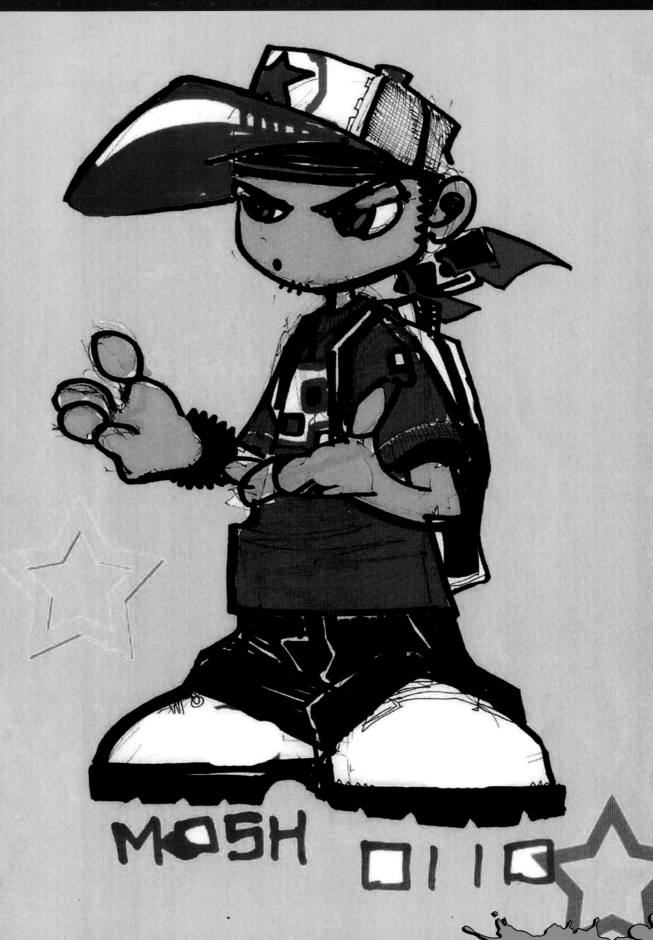

A
Accessories, 78–80
Acrylics, 13
Aggression, 98, 99
Anger, 90, 92, 94, 97
Ankle socks, 76–77
Artists, analyzing of, 140
Attention, 94
Attitude, 87, 92, 135

B
Bags, 78
Balance, 24, 27, 59, 109
B-ball player, 100
B-boy, 87
B-girl, 89
Block and cube construction, 138, 140
Body, human, 43–47, 57–60
Body language, 90–91
Boombox, 35
Boredom, 94
Bracelets, 79
Bristol paper, 14
Brushes, 13, 14, 16
Bubble goose, 73

C
Canvas, 14
CD players, 38
CDs, 17
Cellphones, 39
Characterization, posture and, 82–101
Cheek bones, 55, 56
Circle, 23, 44
Class, 89
Clothing, 61–63, 64–81, 110
Coat, 73
Communal women, 88
Compass, 15
Composition, 24, 114
Cone, 26
Construction, 32–63, 125, 129, 134, 138
Cops, 101, 111
Cube, 26, 35, 36, 138, 140
Curves, 15, 35, 36, 127

D
Dancers, 17, 108–109, 121
Depth, 24, 26, 27
Dimension, 26
Discontent, 92
Distance, 24, 27
DJ, 36, 91, 121
Drawing pad, 14
Dustbrush, 16

E
Earphones, 37
Earrings, 79
Elbows, 46
Emotion. *See* Expressions
Environments, 27
Eraser, 16
Exaggerating proportions, 126
Expressions, 92–98
Eyes, 48, 49, 92, 93, 94, 95–96

F
Facial expression, 92–99, 98
Fathead marker, 12
Feet, 53, 54, 77
Female figures, 57–60
Female heads, 55–56
Femininity, 58
Fingers, 51–53, 90
Footwear, 76–77
Foreshortening, 50–51, 53, 60
Forms, 20–21, 22, 26–29, 30–31, 43–45, 68, 71, 134, 140, 141
Foundation, 135
French curves, 15
Fruit, drawing of, 30

G
Gear, 61–63, 64, 81, 110
Gesture drawing, 86–88, 104, 107, 136, 138
Goggles and mask, 13
Golden area, 116
Grace, 59, 89, 137
Graffiti, 13, 17, 114–115, 129, 141

H
Hair, 75
Handbags, 78
Hands, 46, 51–53, 90, 91, 99
Hat, 125
Head, 44, 45, 46, 48–49, 55–56
Headgear, 74, 75, 125
Headphones, 37
Hierarchical men, 88
Hip-hop, 7–8
Hips, 57, 59
Hoodies, 67
Household items, 23, 28, 31
Human body, 43–47, 57–60

I
Inanimate objects, 131
Inks, 13, 16

J
Jaw, 55, 56
Jeans, 66, 68, 70
Jewelry, 79, 80
Joints, 45, 51

K
Knapsacks, 78

L
Legs, 91
Life sketching, 14, 30, 84–86, 88, 101, 107
Light, 30
Lightbox, 14
Limbs, 44, 45, 60
Line thickness, 66, 127–129
Lips, 55, 56, 92, 93, 94, 97
Locomotion, 112–121
Logos, 66

M
Markers, 12, 13, 14
MC, 35, 87, 98, 99, 121, 126, 137, 142
Measurements, 46–47, 48
Mechanical pencil, 12
Microphone, 35
Midsection, 44
Mouth, 49, 97
Movement, 24, 36, 45, 51, 53, 57–60, 66, 70, 86, 87, 91, 98, 102–111, 114, 129
MP3 players, 38

N
Negative space, 120, 121
Nose, 49

O
Oil marker, 12
Oils, 13, 16
Oval, 44
Overlapping, 24, 27, 115, 116

P
Paints, 13, 14, 16
Paint thinner, 16
Paper, 14, 16, 27
Park, 107
PDAs, 39
Pelvis, 45, 57
Pencils, 12, 14, 16
Pendant, 80
Pens, 13, 14
Permanent marker, 12
Personality, 86, 88, 135
Perspective, 60
Pilot pen, 12

Players, portable, 38
Playing, 107
Posture, 82–101, 135, 142
Pride, 87
Proportions, 59, 68, 126
Protractor, 15
Public sketching, 84–86, 88, 101, 107

R
Rags, 16
Random combinations, 24, 27
Rectangle, 23, 44
Reference materials, 17, 84, 141
Rhythm, 129, 142
Robot, 58
Ruler, 15
Rules, 133, 139
Running, 107

S
Safety, 85
Schemer, 90
Sedans, 42
Sexiness, 89
Shading, 30, 73, 130
Shadows, 27, 30
Shapes, 20–21, 22, 23–25, 30–31, 43–45, 59, 68, 71, 134, 141
Shoulders, 57
Size, gear, 66, 67, 68, 70
Sketching, life, 14, 30, 84–86, 88, 101, 107
Sketch pad, 14
Slip-ons, 76
Sneakers, 76–77
Socks, 76–77
Solidarity, 25
Speakers, 36
Sphere, 26, 35, 45
Spray paint, 13, 14
Square, 23, 44
Stencil, 15
Style, 89, 122–132
Supplies, tools and, 10–19, 126, 130, 136
Surprise, 94
SUVs, 40, 41

T
Talking, 97
Tape, 16
Technique, 130
Teeth, 94, 97
Text messaging devices, 39
Thighs, 46
Tools and supplies, 10–19, 126, 130, 136
Toughness, 90
Tracing paper, 14, 16, 27
Triangle (shape), 23, 44
Triangle (tool), 15
True-form curves, 15
T-shirt, 66, 68, 69
T-squares, 15
Tube, 26, 35, 45
Turntables, 36
Turpentine, 16

V
Van, 41

W
Waist, 46
Walking, 107
Watercolors, 13
Water jar, 16
Water-resistant paint, 13
Wedge, 26
Weight, 24, 27, 59, 66, 73, 109, 127, 140
Windbreaker suit, 70
Workplace, 18–19
Wrinkles, 66, 67, 69, 71

Y
Yelling, 97